MY LIFE IN JAZZ

Vic Lewis

in collaboration with
Robert Feather

Layout and design by
Adrian Korsner with Vic Lewis.

additional artwork by
Barry Weitz

Intro – Memoirs of a Lifetime in Jazz

Every inch of the inner sanctum is packed with CDs, records, books, magazines, and jazz memorabilia. Vic Lewis and I sit listening to the sounds of some of his enormous collection of jazz, interspersed with Vic's own recordings of nostalgic echoes of Downtown New York from the '30s right up to the latest work he has recently completed with Andy Martin and Christian Jacob.

I reach up to take down a photograph album from one of the shelves and as the pages flick over realise that there are not only musical records in this temple of jazz but emotive and historic photographic records that span the intervening years right up to today. A bayou tapestry of jazz history seen through the eyes of a man who is without doubt one of Britain's greatest witnesses to the jazz era.

During my long conversations with Vic he recounted memories of his first trip to America in 1938, where with the help of Leonard Feather, my cousin, meetings had been arranged with Joe Marsala, Joe Bushkin, and Buddy Rich at the Hickory House on 48th Street, New York where he was able to sit in and play guitar with these jazz greats. Just as memorable to him were meetings with Bobby Hackett, Eddie Condon, and Pee Wee Russell, arranged for him at Nick's Club in Greenwich Village. Here Vic enjoyed himself in the company of Tommy Dorsey, and Jack Teagarden. Sidney Bechet was part of the supporting group with Zutty Singleton and Wellman Braud.

The man who had shepherded Vic around Downtown New York, Leonard Feather, had plucked George Shearing out of Vic's earliest of bands and whisked him away to America where they both progressed to become, respectively, legends of jazz criticism and piano, and long time friends of Vic's.

With the start of World War II, Vic joined the RAF in 1939 and was posted to Bomber Command HQ. Later the Buddy Featherstonehaugh Quintet was posted to the same location and was joined by Vic Lewis, turning it into a Sextet. The band included Don Macaffer, who taught him the trombone, and drummer Jack Parnell, with whom he was later to co-run their own band after the War. It was during the War period that Vic was also to meet Glen Miller, and record with Sam Donahue, Jimmy McPartland, and Johnny Mince, the latter who he had already encountered through meeting Tommy Dorsey, Johnny Best and numerous other jazz musicians in 1938.

The Vic Lewis Jazzmen changed its style and was enlarged to form the Vic Lewis Orchestra, enjoying widespread acclaim over the next decade. Another reincarnation, The Vic Lewis Orchestra toured the US in 1956, 1958, 1959 and 1960, ending up at the Birdland Club, in New York, in front of a glitterati of celebrities there to hear the final concert of the tour.

One of the greatest moments in Vic's long career was when he was introduced by Stan Kenton, in 1950, to go up on stage at Carnegie Hall, New York, and be presented as 'England's Stan Kenton' and to conduct the Innovations Orchestra. A few years later he had the added pleasure of sitting in as a trombonist for a Kenton Orchestra concert at the Alhambra, Paris, when Bob Fitzpatrick was taken ill until. He was only able to return later in the concert.

Like many of the other jazz giants Vic encountered, and played with in those early years -Louis Armstrong, Django Reinhardt, Stephané Grappelli, Mo Zudekoff (later known as Buddy Morrow), Gerry Mulligan and Stan Kenton became lifelong friends.

The story goes on and on with the involvement, recording and performance of Vic in concerts in the UK and around the world, most recently with the producing and recording of jazz musicians from the West Coast, Andy Martin, Christian Jacob- as well as musicians from the UK.

Shearing was not the only great musician to have played in and been nurtured under Vic's UK band baton. The list reads like a who's who of every major British jazz personality who would later become leaders of their own bands or groups in their own right …. Kenny Baker, Jimmy Skidmore, Tubby Hayes, Vic Ash, Dudley Moore, and Ronnie Scott. Others, like Ken Thorne, a pianist with Vic's early band, was to go on to become an internationally recognised musical arranger, and the only Britisher to win an Oscar in his category. Vic adds that of all the people responsible for the direction of his musical career, "in a large way", Ken was his closest mentor and friend.

Many of these momentous moments in the life of Vic Lewis are captured through the photos in this book. Many have never been published before and constitute a unique record of 20th century musical history. Stroll into the houses of some of the most famous musical arrangers, Henry Mancini, Shorty Rogers, Johnny Mandel, Nelson Riddle. Stare in wonder at the mellowed mahogany of Kenton's piano in his Beverly Hills home.

Robert Feather

But now let Vic tells his own story in photographic words…………

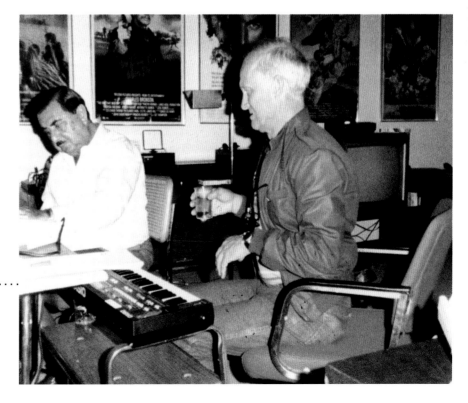

Ken Thorne runs some musical ideas for a recent film score, past Vic.

My Life In Jazz - *A word from Vic*

To be more specific, this is my life in jazz mainly through the medium of pictures. Inevitably many of the pages include pictures of me in action or just mixing with a wide range of jazz musicians, arrangers, composers, and related personalities. Where other people are included they are of special importance to me as friends and colleagues. People who I have interacted with over the years, sometimes initially as fellow musicians but in many instances they became life long friends.

Jazz is improvised – but an arranger makes the backings and surroundings to the actual themes so much more interesting and complementary. So in big band jazz this input is vital in its ability to change the different sounds and styles that go to make up the individualism of each band or group.

As we travel through my life we also travel through what is essentially a kaleidoscope of British and American jazz history seen through the eyes of someone who has been privileged to have met and played with almost every major jazz musician of the 20th century. I have not given up yet and am still active in producing what is, in my view, some of the greatest jazz of the 21st century, featuring amongst others, Andy Martin, Christian Jacob, and Bill Holman.

This career in jazz has extended over seventy years, and the book is roughly split into chronological periods, from the early 1930's right through to the present day. Although some pictures interspersed in these sections are not in any special sequence they are there because they relate to the subject matter and illustrate events and people in my life at the time. At the end of the 70's I became more involved in modern classical music, conducting the Royal Philharmonic Orchestra on a dozen recordings, but never forgetting my jazz roots.

So let's start with the Beginnings, the earliest days when I first formed my own band, back in 1935, and then played with Django Reinhardt and Stéphane Grapelli. The incredible period just before the War when I had the joy of playing in with some of my teenage heroes - at the Hickory House and Nick's jazz clubs in New York Joe Marsala, Joe Bushkin, Buddy Rich, Bobby Hackell, Eddie Condon, Sidney Bechet, Tommy Dorsey, Jack Teagarden…..

In between organising two recording session with some of these American jazz giants I took the opportunity to broaden my outlook by going to Memphis and New Orleans – the original heartland of jazz.

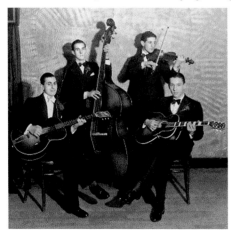

Vic Lewis String Quartet (1935).

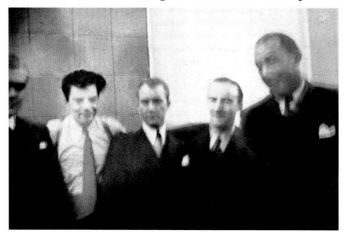

The First session at Baldwin's recording studios, New York, October 1938.
(l to r) Dave Bowman Joe Marsala Eddie Condon Bobby Hackett Zutty Singleton
(Taken on Vic's box camera)

Acknowledgements

These are memorable pictures of my jazz life.
Many of the snapshots I took myself and to other photographers
I owe a debt of gratitude for them being there to record the moments.
Where known I have given credit to the photographer.
Where no credit has been given, it is because
I just don't know (or forgot) who took the shots.
I hope they will forgive the omission but I am none the less
grateful for their contributions.

I could not have produced this book without the hard work and
help of Robert Feather and Adrian Korsner.

**To my dearest wife Jill, to whom this book is dedicated,
"Thank you for putting up with the years of clutter."**

<Vic and Robert Feather

*Bill Holman, Vic
and Adrian Korsner>*

SECTIONS

Each of the contents in this book's colour coded sections are grouped in roughly chronological sequence, but some sections more conveniently pull together subjects that are of common interest in no particular order – a bit like the progress of my own life!

Early Days and New York 1

The War Years and Late 40's 6

The 50's 15

The 60's 52

Signed Memories 58

Arrangers and Composers 70

More Friends 90

Concerts 124

The Project Years 128

Early Days and New York

Vic's first quartet was formed in 1935, modelled on the influences of Stephané Grappelli and Django Reinhardt. Shortly after that he took a trip to New York where the heavens literally opened. There, for a period of about six months, he played with and encountered many of the all-time greats of American jazz people who were in many instances to become life-long friends, as the following photographs illustrate.

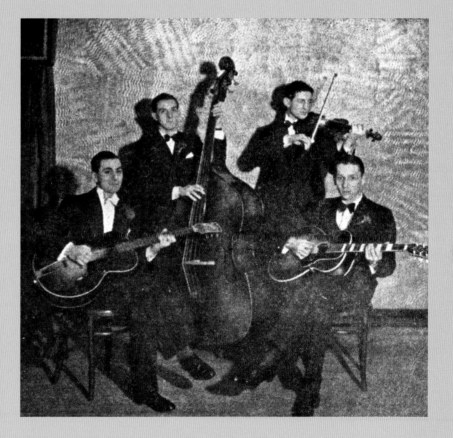

Vic Lewis Swing String Quartet 1935.
Ron Burton (vl) Alan Hanes (gtr) Joe Muslin (bs)

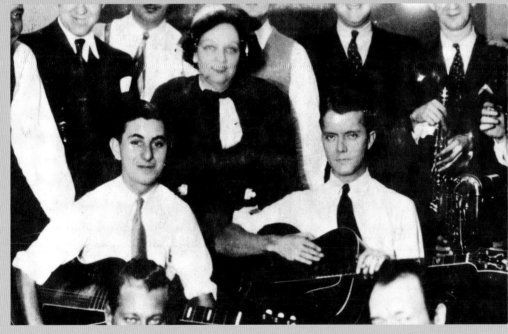

Guitar hero Eddie Condon.

Some of the sax section, (l to r)
Johnny Mince (cl), Vic, Hymie Schertzer (alt),
Skeets Herfurt (tnr), Gene Traxler (bs)

Tommy Dorsey in a contemplative mood,with singer Edythe Wright,
during a rehearsal for Kool cigarettes commercial in New York 1938.
(Photo Vic Lewis).

The trumpet section, (l to r)
Vic, Moe Zudekoff (later Buddy
Morrow) and successor to leader
of the Tommy Dorsey Band,
Charlie Spivak, Lee Castle (back)
and Yank Lawson.

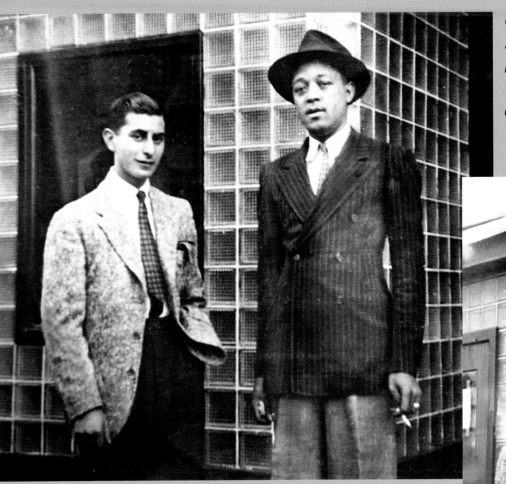

Outside The Famous Door Nightclub on 52nd Street, New York in Autumn 1938. Lester Young (left, tnr) and Freddie Green (below, gtr). Waiting for 'The Boss' (Count Basie), who eventually arrived.

3

Second session at Baldwin's Recording Studios, New York, in October 1938.

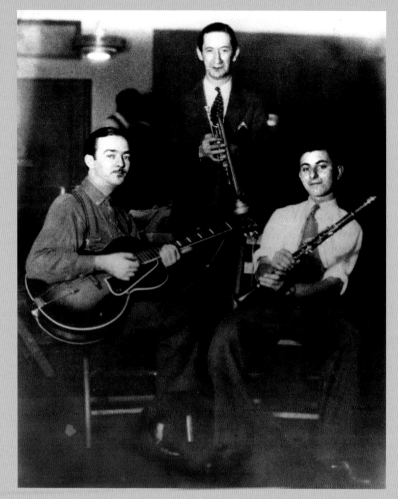

Left to right, Bobby Hackett, Pee Wee Russell and Vic Lewis swap instruments for fun. (Taken by a proper camera).

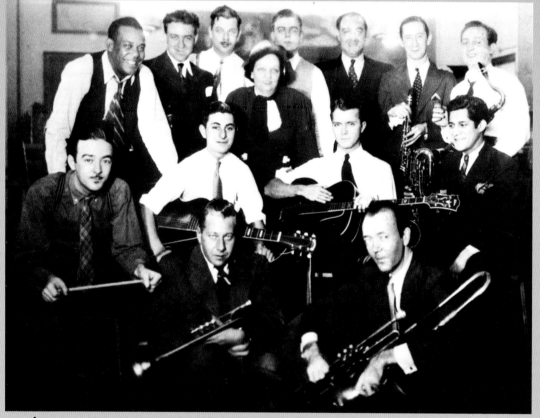

Left to right: "Zutty" Singleton, Hughes Panassie (one of the leading jazz critics in the world at that time), Brad Gowans, Dave Bowman, Nick Longeth (manager and owner of Nick's Club), Pee Wee Russell, Josh Billings, Middle row: José Carroll. Seated: Bobby Hackett, Vic Lewis, Eddie Condon, Ernie Caceres. Front: George Wettling and Pat Condon. (Taken on Vic's box camera)

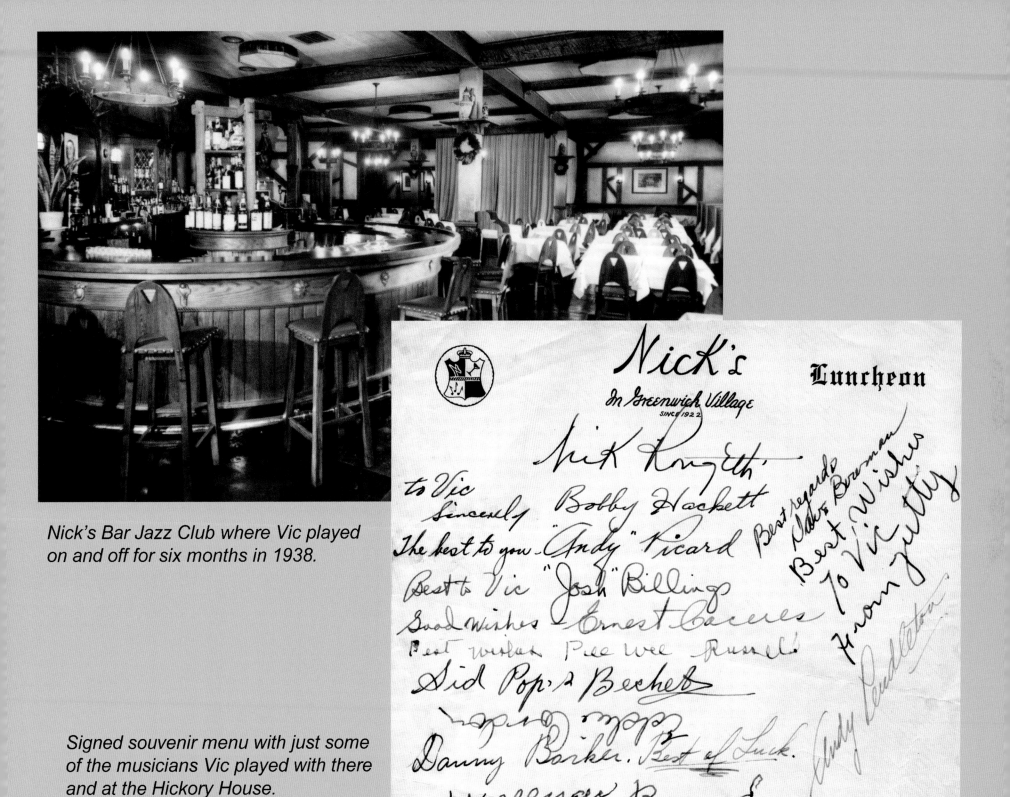

Nick's Bar Jazz Club where Vic played on and off for six months in 1938.

Signed souvenir menu with just some of the musicians Vic played with there and at the Hickory House.

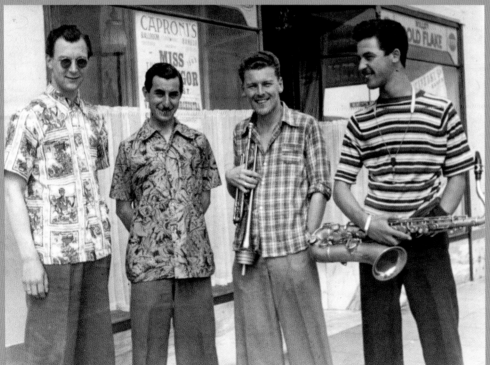

The War Years and '40s

During service in the Royal Airforce, from 1939-45 I played with the Buddy Featherstonehaugh Bomber Command Sextet where I first met Jack Parnell. On in between days I recorded several entente cordiale sessions with visiting American band musicians and at the end of the War Jack and formed our own band and my chosen career was underway.

The Jazzmen at the very first recording session for a record company, EMI, made on 12th February 1944. Left to right: Derek Hawkins, Dick Katz, Ronnie Chamberlain, Vic Lewis, Billy Riddick, Jack Parnell, Wally Ridley (chief producer EMI.), Charlie Short.

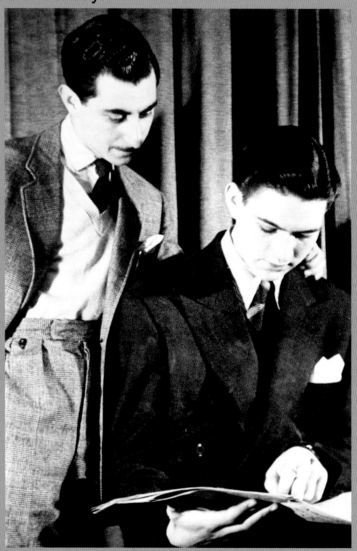

Peter Coleman (drs), Johnny Shakespeare (tpt), Danny Moss Bangor, N.Ireland 1947. Photo Al Ferdman.

Close friends with Jack Parnell during and after World War II, their joint band was Vic's first venture into big band performances.

6

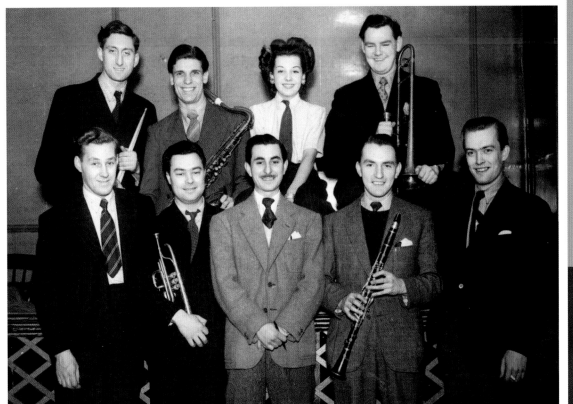

The Vic Lewis Jazzmen.
Back, Harry Singer (drs), Jimmy Skidmore (tnr)
Dorothy Clinton (vcl) Jimmy Wilson (tbne).
Front, Johnny Quest (bs), Reg Arnold (tpt),
Ronnie Chamberlain (reeds) and Ken Thorne.

One of the last pictures of Glen Miller taken in December 1944, before his fatal flight to Paris. Taken at the London Jazz Jamboree.

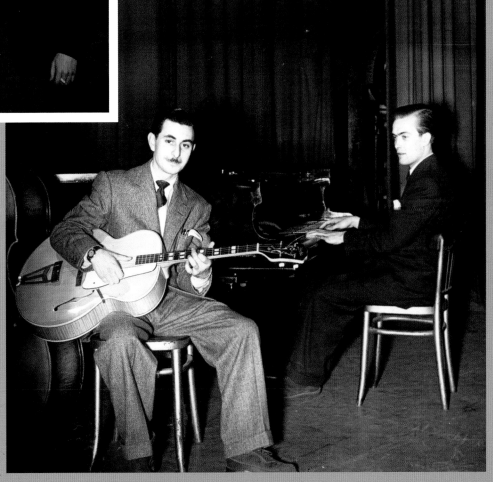

Vic with his beloved white Gibson, with Ken Thorne.

7

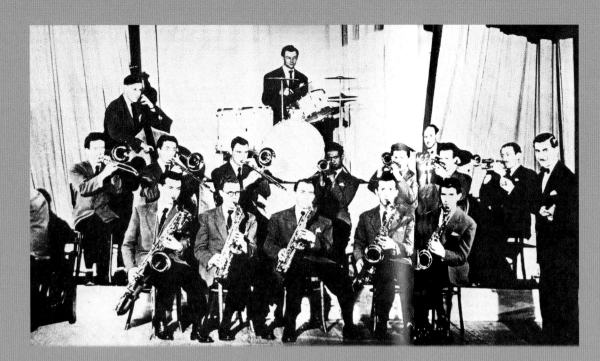

Conducting the band in the hit movie
Date With A Dream. 1948. Also starring:-
Terry Thomas. Jeannie Carson and
Norman Wisdom. Vic wrote all the
original tunes for the film
except for one written by Ken Thorne.

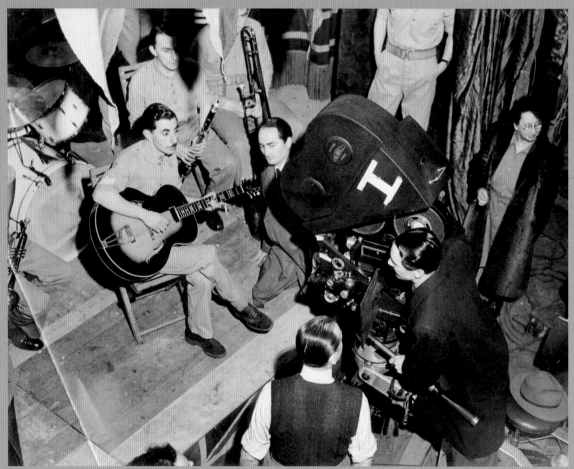

Facing the cameras on Date With A Dream

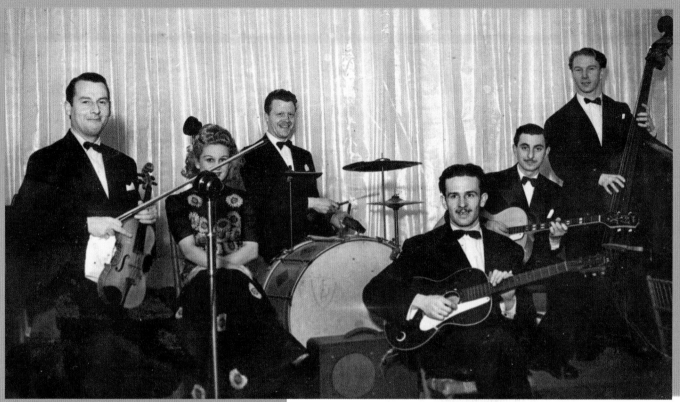

The Stephane Grapelli Quintet playing at Bates' Club, Mayfair, where Vic had a six month residency with the band in 1946. (l to r) Stephane, Edna Kaye (vc) Unknown drummer and guitarist, Tommy Bromley (bs).

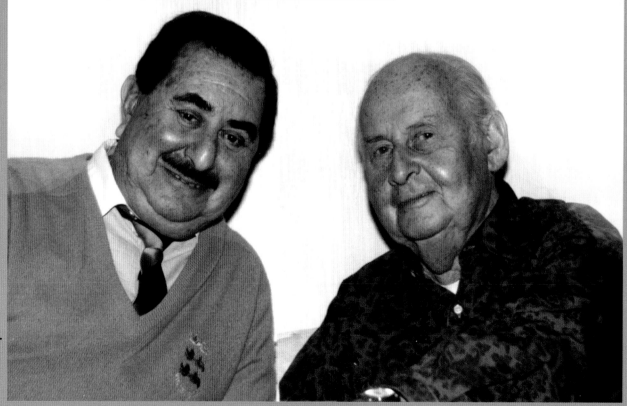

Vic and Stephane, fifty years later at a rehearsal at the Barbican in London.

9

ANGLO-AMERICAN JAZZ

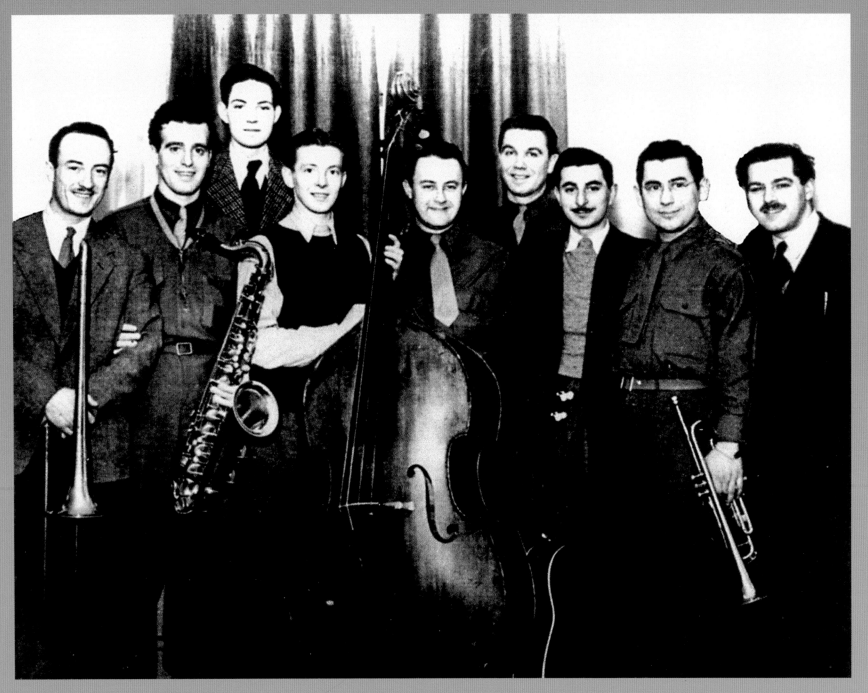

First Recording Session, London, mid- February, 1944.
A recording session that Vic Lewis formed. Left to right: George Chisholm (trombone), Joe Gudice (tenor sax),
Jack Parnell (drums), Charlie Short (bass), Billy Jones (trumpet), Johnny Mince (clarinet), Vic Lewis (guitar/vocals),
Jake Koven (trumpet), Dick Katz (piano).

ANGLO-AMERICAN JAZZ

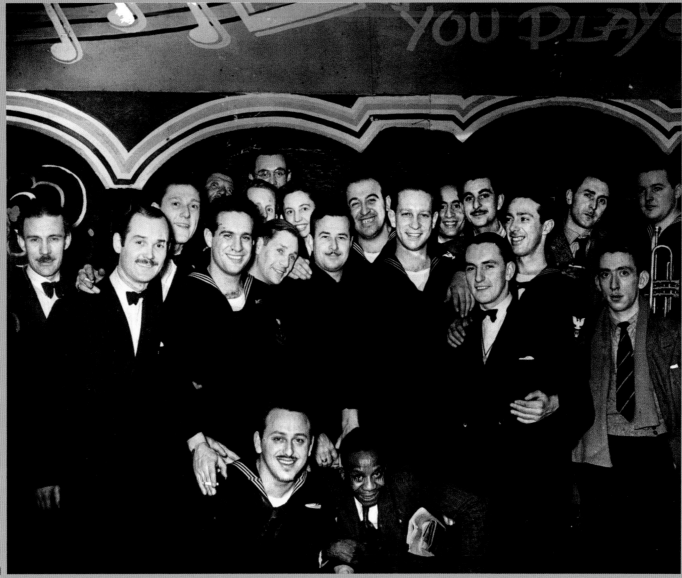

Second Session

When the US Navy Band came to England in 1944, they played with some of the Vic Lewis Jazzmen some of whom are seen in the picture together with other British jazz musicians who joined the party at the Nuthouse Nightclub, Carnaby Street, London. When the US band returned to America after a tour of the Far East, the band was taken over by Sam Donahue for a tour of Europe. Many of the original members in this picture include: Frankie Beach (1st right), Ralph Lapolla (3rd from right), Sam Donahue (6th from right), Johnny Best (8th from right), Vic Lewis (3rd from right top row),Rocky Caluccio (between Johnny Best and Sam Donahue), Gerry Moore (between Sam Donahue and Vic Lewis), Tommy Mc Quarter (2nd from right), Ronnie Chamberlain (2nd from left), Tak Takvorian (4th from left), Carlo Krahmer (to left of Tak Takvorian), Carlo Krahmer's wife Greta (behind him), Bert Howard (3rd from left). Front kneeling: Nuthouse Club master of ceremonies (right),Don Jacoby (left).

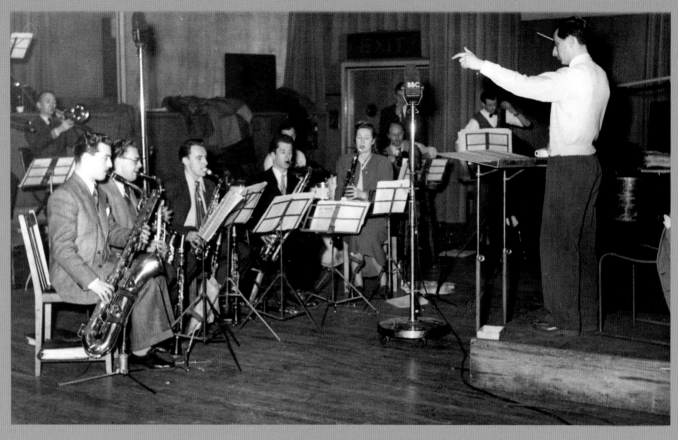

Conducting the orchestra at a BBC recording session in 1947.

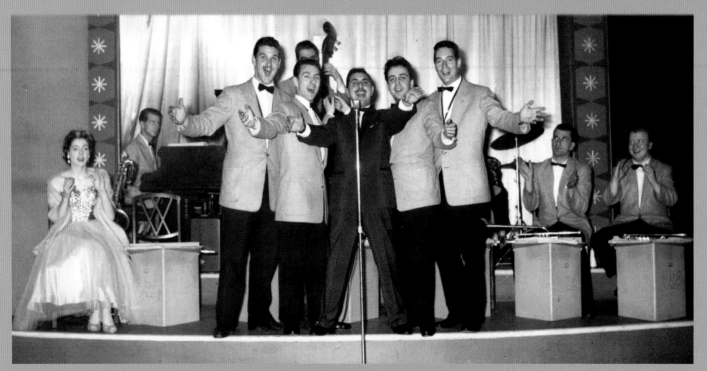

Singing with the Quinks and Irma Logan

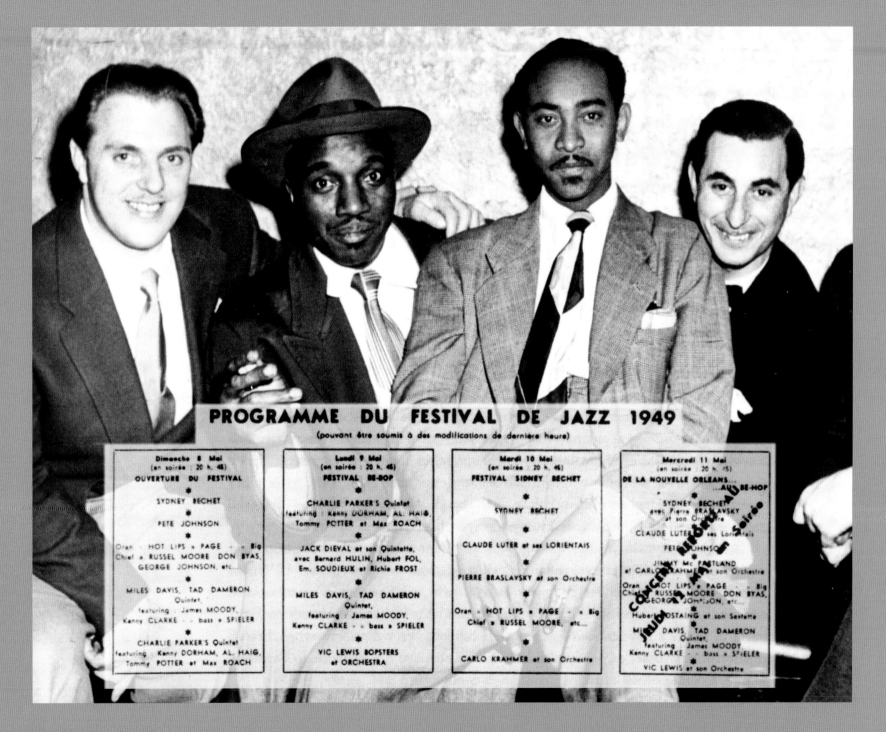

PROGRAMME DU FESTIVAL DE JAZZ 1949

(pouvant être soumis à des modifications de dernière heure)

Dimanche 8 Mai (en soirée : 20 h. 45)	Lundi 9 Mai (en soirée : 20 h. 45)	Mardi 10 Mai (en soirée : 20 h. 45)	Mercredi 11 Mai (en soirée : 20 h. 45)
OUVERTURE DU FESTIVAL	FESTIVAL BE-BOP	FESTIVAL SIDNEY BECHET	DE LA NOUVELLE ORLEANS... ...AU BE-HOP
SYDNEY BECHET	CHARLIE PARKER'S Quintet featuring : Kenny DORHAM, AL HAIG, Tommy POTTER et Max ROACH	SYDNEY BECHET	SYDNEY BECHET avec Pierre BRASLAVSKY et son Orchestre
PETE JOHNSON	JACK DIEVAL et son Quintette, avec Bernard HULIN, Hubert FOL, Em. SOUDIEUX et Richie FROST	CLAUDE LUTER et ses LORIENTAIS	CLAUDE LUTER et ses Lorientais
Oran « HOT LIPS » PAGE - « Big Chief » RUSSEL MOORE DON BYAS, GEORGE JOHNSON, etc...	MILES DAVIS, TAD DAMERON Quintet, featuring : James MOODY, Kenny CLARKE - - bass » SPIELER	PIERRE BRASLAVSKY et son Orchestre	PETE JOHNSON
MILES DAVIS, TAD DAMERON Quintet, featuring : James MOODY, Kenny CLARKE - - bass » SPIELER		Oran « HOT LIPS » PAGE - « Big Chief » RUSSEL MOORE, etc...	JIMMY Mc PARTLAND et CARLO KRAHMER et son Orchestre
CHARLIE PARKER'S Quintet featuring : Kenny DORHAM, AL HAIG, Tommy POTTER et Max ROACH	VIC LEWIS BOPSTERS et ORCHESTRA	CARLO KRAHMER et son Orchestra	Oran « HOT LIPS » PAGE - « Big Chief » RUSSEL MOORE DON BYAS, GEORGE JOHNSON, etc...
			Hubert ROSTAING et son Sextette
			MILES DAVIS, TAD DAMERON Quintet, featuring : James MOODY, Kenny CLARKE - - bass » SPIELER
			VIC LEWIS et son Orchestre

Paris Jazz Festival when the Vic Lewis Bopsters and Orchestra were chosen to play alongside some of the greatest Jazz musicians from around the world, such as Charlie Parker, Miles Davis and Sidney Bechet. (Above l to r), Howard Luff (lead tpt with Vic), Hot Lips Page (tpt), and Don Byas(tnr) (sitting on Hot Lips' and Vic's laps).

ALL OVER THE COUNTRY PROGRESSIVE MUSICIANS AND FANS ARE ASKING—

What will be the new Stan Kenton policy?

EVER since the announcement in the MELODY MAKER of June 9 that Stan Kenton was to re-form his band, with "a wider variety of music," my orchestra and I have been constantly asked by fans wherever we have played what we think of this apparent "commercial trend" which he proposes to feature.

Many of the fans have, indeed, had such misgivings about what kind of the future Kenton music would be that I think I should set out my own views of what has happened to Stan, and why he has decided on this course.

Here is a behind-the-scenes glimpse of the uncompromising Kenton attitude towards music, and a suggestion as to why (and how) he intends resuming bandleading, by Britain's No. 1 exponent of progressive jazz,

VIC LEWIS

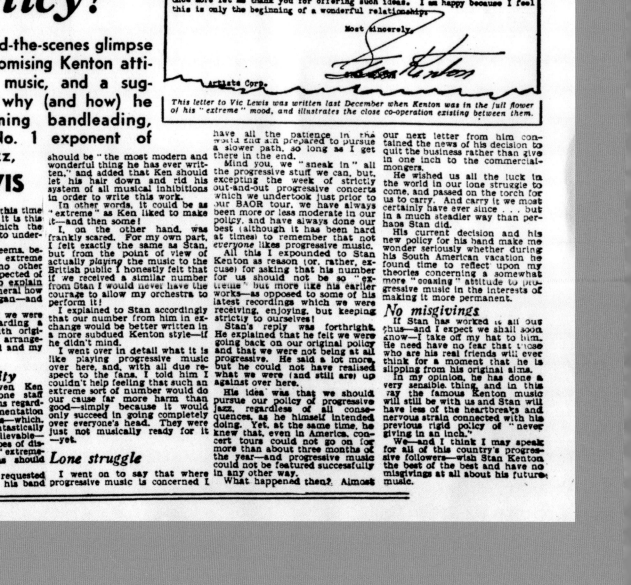

He can write the trumpets up to G's and A flats above high C, and he can also be as free with the trombones. One favor I do ask is to please not write any clarinet stuff as we do not use them. Somehow it is a sound I just cannot tolerate. If this were finished in three or four months it would be soon enough. He can make it a short works, which would mean three to five minutes, or longer if he wishes.

This will kind of bring you up to date on everything so far. I will certainly be looking forward to hearing from you again. Somehow I feel that this is the beginning of a most exciting time in modern music.

Once more let me thank you for offering such ideas. I am happy because I feel this is only the beginning of a wonderful relationship.

Most sincerely,

Artists Corp.

This letter to Vic Lewis was written last December when Kenton was in the full flower of his "extreme" mood, and illustrates the close co-operation existing between them.

Joint outlook

It is by now a known fact that Stan and I exchanged much correspondence about our respective bands and joint musical outlook. I was personally very disappointed when he first told me that he intended to give up the business, and I did all I could at that time to dissuade him from such drastic action.

Even in my last letter to him I asked whether he had changed his mind after all, and I added that I couldn't help feeling that in time to come we would be hearing still further and greater efforts from him in the world of music. This notwithstanding the fact that his previous denials had been most emphatic.

Somehow I could never believe that he could give it all up, just like that. Music meant a very great deal to Stan—progressive music in particular, of course—and while I realised that his health must have been causing him some concern. I think I always had at the back of my mind the thought that he would one day make a come-back with a band.

Apparently his recent South American holiday has done much for him, both in health and outlook. And he has decided to lead a band once more—but this time with a difference! And it is this difference in policy which the fans are finding it hard to understand.

Stan Kenton has, it seems, become such a byword in extreme progressive jazz that no other kind of music can be expected of him. So I would like to explain to the music world in general how I think this change began—and exactly what it means.

Around last December we were exchanging letters regarding a reciprocal agreement with original compositions and arrangements between his band and my own.

Extreme modernity

He had already given Ken Thorne, my number one staff arranger, full instructions regarding the Kenton instrumentation and pitches for the brass—which, incidentally, were fantastically high and almost unbelievable—and we were in the throes of discussing the extent of "extremeness" the compositions should feature.

Stan, for his part, requested that Ken's number for his band should be "the most modern and wonderful thing he has ever written," and added that Ken should let his hair down and rid his system of all musical inhibitions in order to write this work.

In other words, it could be as "extreme" as Ken liked to make it—and then some!

I, on the other hand, was frankly scared. For my own part, I felt exactly the same as Stan, but from the point of view of actually *playing* the music to the British public I honestly felt that if we received a similar number from Stan I would never have the courage to allow my orchestra to perform it!

I explained to Stan accordingly that our number from him in exchange would be better written in a more subdued Kenton style—if he didn't mind.

I went over in detail what it is like playing progressive music over here, and, with all due respect to the fans. I told him I couldn't help feeling that such an extreme sort of number would do our cause far more harm than good—simply because it would only succeed in going completely over everyone's head. They were just not musically ready for it—yet.

Lone struggle

I went on to say that where progressive music is concerned I have all the patience in the world and am prepared to pursue a slower path, so long as I get there in the end.

Mind you, we "sneak in" all the progressive stuff we can, but, excepting the week of strictly out-and-out progressive concerts which we undertook just prior to our BAOR tour, we have always been more or less moderate in our policy, and have always done our best (although it has been hard at times) to remember that not everyone likes progressive music.

All this I expounded to Stan Kenton as reason (or, rather, excuse) for asking that his number for us should not be so "extreme" but more like his earlier works—as opposed to some of his latest recordings which we were receiving, enjoying, but keeping strictly to ourselves!

Stan's reply was forthright. He explained that he felt we were going back on our original policy and that we were not being at all progressive. He said a lot more, but he could not have realised what we were (and still are) up against over here.

His idea was that we should pursue our policy of progressive jazz, regardless of all consequences, as he himself intended doing. Yet, at the same time, he knew that, even in America, concert tours could not go on for more than about three months of the year—and progressive music could not be featured successfully in any other way.

What happened then? Almost our next letter from him contained the news of his decision to quit the business rather than give in one inch to the commercial-mongers.

He wished us all the luck in the world in our lone struggle to come, and passed on the torch for us to carry. And carry it we most certainly have ever since . . . but in a much steadier way than perhaps Stan did.

His current decision and his new policy for his band make me wonder seriously whether during his South American vacation he found time to reflect upon my theories concerning a somewhat more "coaxing" attitude to progressive music in the interests of making it more permanent.

No misgivings

If Stan has worked it all out thus—and I expect we shall soon know—I take off my hat to him. He need have no fear that those who are his real friends will ever think for a moment that he is slipping from his original aims.

In my opinion, he has done a very sensible thing, and in this way the famous Kenton music will still be with us and Stan will have less of the heartbreaks and nervous strain connected with his previous rigid policy of "never giving in an inch."

We—and I think I may speak for all of this country's progressive followers—wish Stan Kenton the best of the best and have no misgivings at all about his future music.

The '50s

Profusely illustrated in this section are the various combinations of jazz groups and bands I formed in England, when big band music was at its peak of popularity. Particularly rewarding was the friendship formed with Stan Kenton and members of his Orchestra during four concert tours of America and Europe. It was then that I had the great opportunity, together with Stan, to meet with officials of the American Federation of Musicians and start negotiations for an historic agreement which culminated In the reinstatement of exchange facilities between American and English musicians. One tremendous high spot for me happened in 1950 when Stan Kenton introduced me to the audience at Carnegie Hall, New York, during the world performance of his Innovations Orchestra. Later, in 1956, I was honoured to play trombone in the Carl Fontana section of the Kenton Orchestra at the Alhambra Theatre in Paris.

With Allan Ganley (drs), Keith Christie (tbn) and Johnny Dankworth.

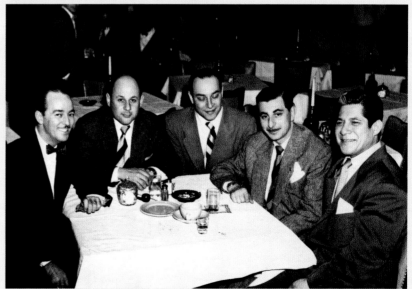

(l to r) Bobby Hackett, Harold Davison, Peanuts Hucko, Ernie Caceres at the Hickory Log N.Y.

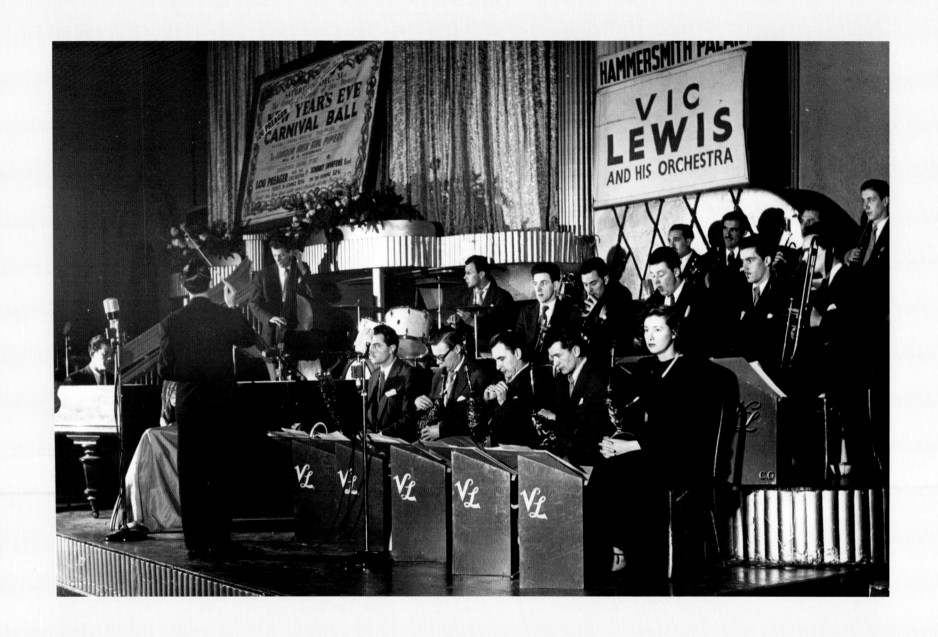

*Conducting the 'Modern Concert Orchestra' in front of 4000 people
at The Hammersmith Palais, London (Dec 20th 1949).
Pete Rugulo and Stan Kenton sent an original composition 'Hammersmith Riff'.
We recorded it on 31st Jan 1950. Kenton recorded it some weeks later, (minus the 5/4 bar).*

Set Up Band Exchange, Pleads Britisher

New York—Vic Lewis, known overseas as the British Stan Kenton, flew here in April in hopes of conferring with James C. Petrillo about the possibilities of breaking down the barriers which prevent England and the United States from exchanging bands. Lewis came armed with permission from the British ministry of labor to set up an exchange deal.

Kenton, who was in town for his Carnegie hall concert, joined Lewis in his discussions with the AFM. Because Petrillo was out of town, they conferred with Rex Ricciardi.

Suggests Trial Period

Lewis, pointing out that the mutual ban resulted from an incident which occurred about 20 years ago, suggested a trial period in which one or two bands would be exchanged between the two countries, each band to have the same number of men, to be paid the same fee, and to play the same number of engagements.

Lewis later said that he made this proposal after Ricciardi had expressed the fear that if the exchange barriers were dropped, there might be an invasion of English musicians, that American bands might have trouble getting the _____ of England, and that musicians may not get what the AFM might consider proper treatment there.

Since Lewis came to this country in an unofficial capacity, he has returned to England to try to get letters from the British musicians union and the ministry of labor setting up guarantees against the things which Ricciardi feared might happen. Meanwhile, Ricciardi has said that he will put Lewis' proposal for a trial exchange period before Petrillo.

British in Favor

"The British musicians are in favor of exchange," Lewis told Down Beat. "We used to have the same difficulty with the European countries, but that has been broken down now and we work on an even exchange basis—one attraction for one attraction. At the present time there are four Dutch musical units working in England and four English units in Holland. Both the United States and England need the exchange badly to stimulate business."

Lewis, who organized his band 3½ years ago, operates as Kenton does here. He plays only for concerts and records. About 70 percent of his book is made up of Kenton numbers. The rest are originals in the same vein by himself and his arranger, Ken Thorn. He uses the same instrumental setup as Kenton except for Kenton's current strings.

In following Kenton as closely as this, Lewis doesn't feel that he is imitating Stan or riding on his coat-tails.

Stan a Creator

"We don't look on Stan as a band leader," he said. "We feel that he has created a new art form, a new and worthy cultural contribution from America. I believe in the music and I want to help spread it. I'm not interested

in being a personality myself."

Originally, Lewis called his music "progressive jazz," as Kenton was doing at the time. But, like Kenton, he found that this frightened people and he now refers to it as "music for moderns."

During his visit to this country, Lewis, who plays trombone, hoped to pick up some of the Kenton arrangements which have not been recorded. At the same time he is trying to get Stan to include some of the Lewis originals in his book.

—wil

Vic Lewis Meets Kenton Cats

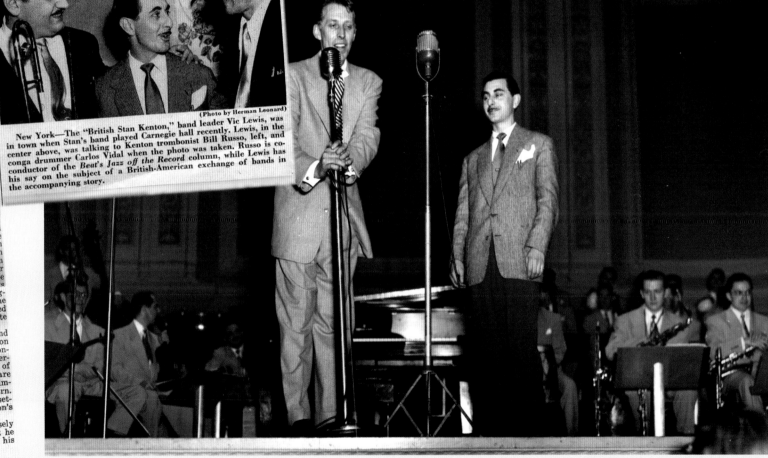

(Photo by Herman Leonard)

New York—The "British Stan Kenton," band leader Vic Lewis, was in town when Stan's band played Carnegie hall recently. Lewis, in the center above, was talking to Kenton trombonist Bill Russo, left, and conga drummer Carlos Vidal when the photo was taken. Russo is co-conductor of the *Beat's Jazz off the Record* column, while Lewis has his say on the subject of a British-American exchange of bands in the accompanying story.

After the war, we were starved of live appearances from American artists. There was mutual fear and misunderstanding between the unions in both countries. Together with Stan we started a movement to overcome this problem, which would be inconceivable today. It was to take five or six years of top level negotiations before an agreement was finally hammered out and musicians and artists of all types were able to travel back and forth across the Atlantic to perform.

How different would history have been if, for example, the Beatles had not been able to perform in America or Sinatra in England?

Stan Kenton introduces me, as a British bandleader at Carnegie Hall Photo Herman Leonard.
(Feb 1950) "One of the high spots of my life!"
In the background (rt) Bob Cooper and Art Pepper (saxes).

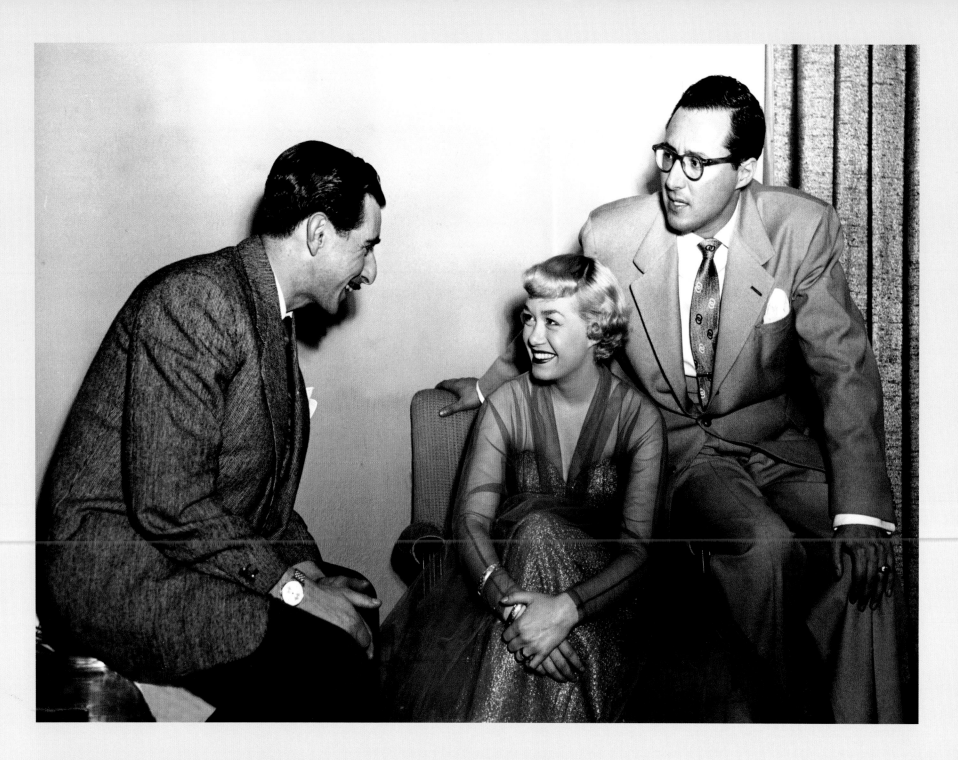

Meeting June Christy with Pete Rugulo for the first time. Feb 1950.
We remained bosom friends from then on. (Photo Herman Leonard)

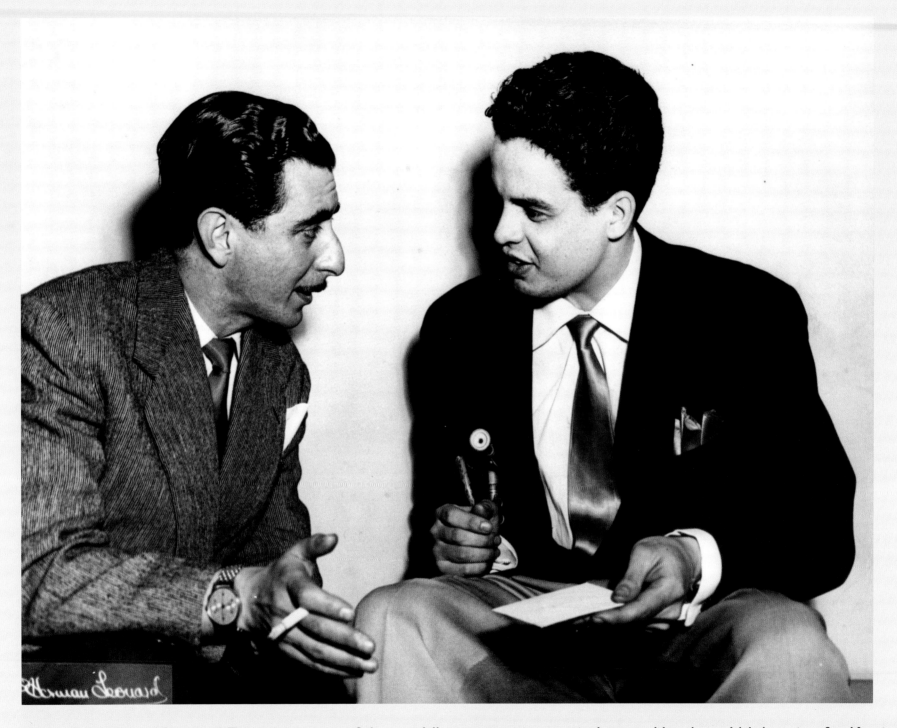

With, Canadian, Maynard Ferguson, one of the world's greatest trumpet players. He played high notes for Kenton with such effortlessness and is still doing it today. Since the early 50's he has led his own orchestra and attracted world wide attention. I managed him for a while in the 1960's when even playing behind the Iron Curtain in Prague, he was idolised by the jazz fans. *Photo Herman Leonard.*

1952 'The New Music'

The orchestra recorded 4 sides on record, three sides arranged by American Dick Allen and one side 'JD to VL' by John Dankworth.

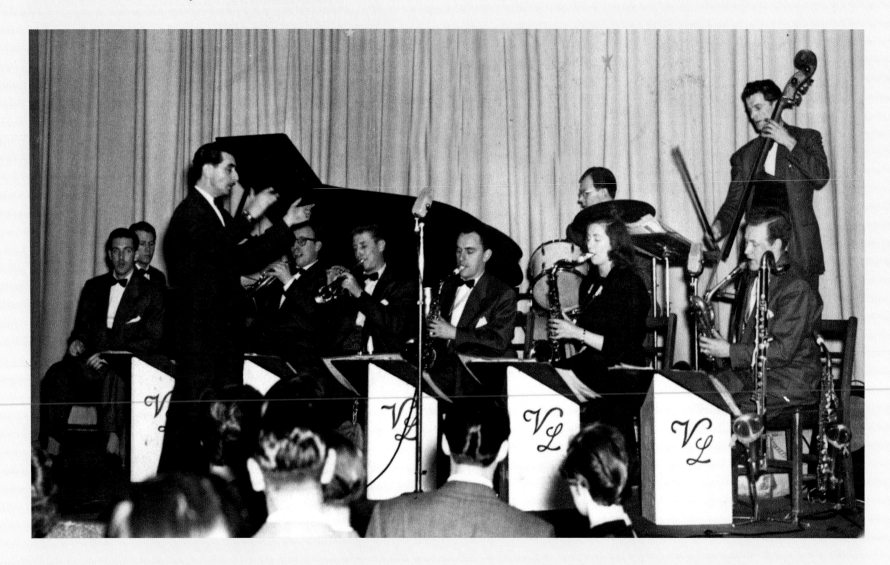

*Johnny Green (v) ,Clive Chaplin (p), Tommy Smith (frh), Bert Courtley (tpt),
Ronnie Chamberlain, Kathy Stobart, Jimmy Simmons (saxes), Martin Gilboy (bs), Peter Coleman (drs).*

Conducting The Ramblers and The Skymasters (two famous Dutch orchestras) and the Vic Lewis Orchestra together at The Concertegbouw, Amsterdam (late 1949) (photo Wouter Van Gool)

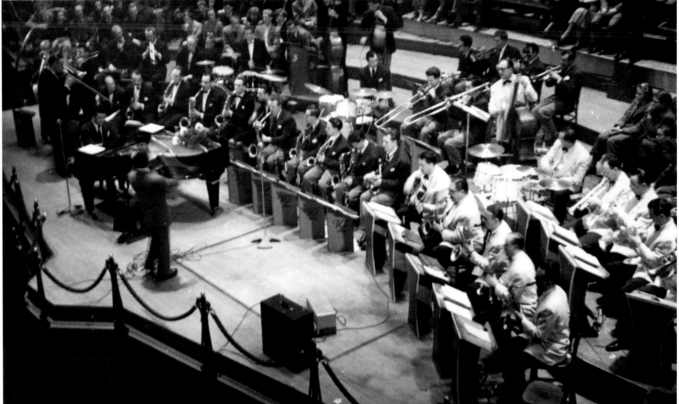

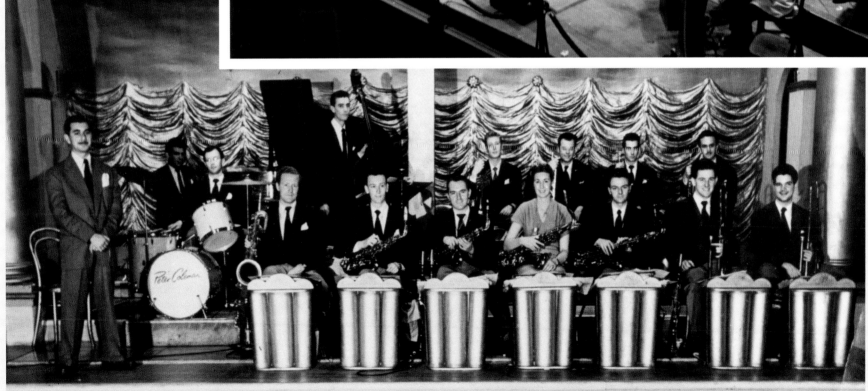

"The best band I ever had" (Vic). Arthur Greenslade (pno), Peter Coleman (drs), Peter Blannin (bs), Bert Courtley, Peter Winslow, Terry Lewis, Bill Sowerby (tpts), Johnny Keating, Jack Botterill (tbns), Ronnie Chamberlain, Derek Humble, Peter Warner, Kathy Stobart, Jimmy Simmons (saxes).

The first band with Jimmy Skidmore (tnr), Ronnie Chamberlain (alt) and Ken Thorne (pno). December 1946.

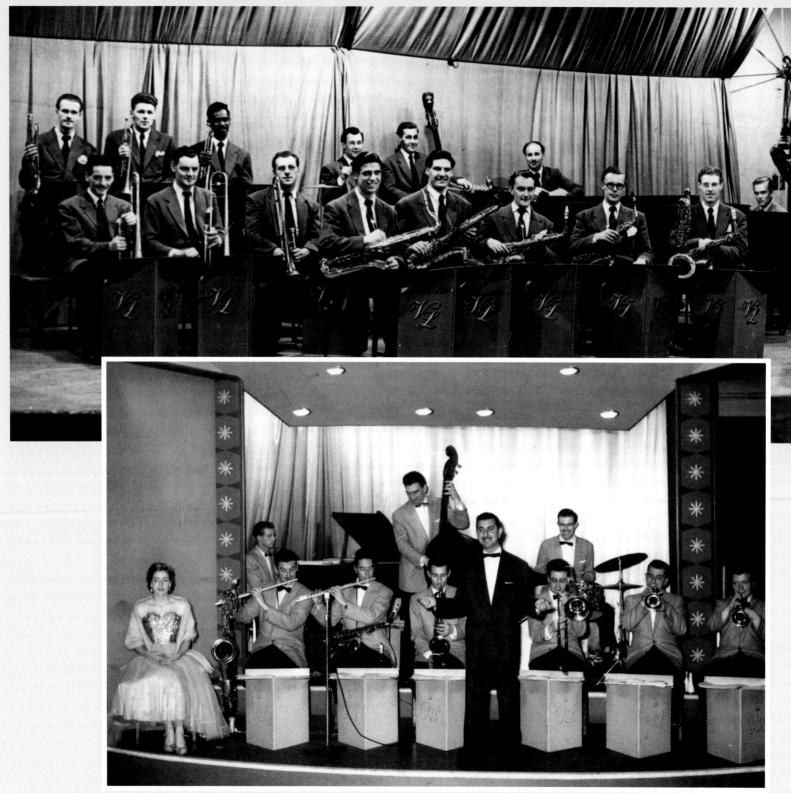

Interim period, smaller group 1956-57.

Orchestra re-formed after 'Music For Moderns' (Sept/Oct 1950)

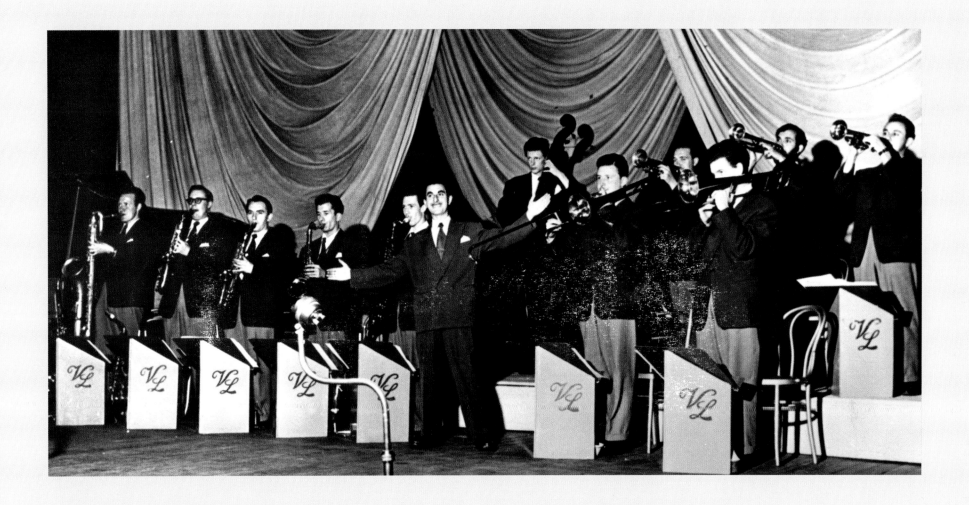

Harry Finch, Paul Berman, Denis Shirley, (tpts). Don Lang, Johnny Keating (tbns).
Jimmy Simmons, Peter Howe, Ronnie Chamberlain, Vince Bovil, Bob Efford, (saxes),
Arthur Greenslade, (pno), Alan McDonald (bs), Peter Coleman (drs).

The Brass Section: The best trumpet section ever.
Bert Courtley, Stan Reynolds, Ron Simmons, Terry Lewis.
Listening today, with a few exceptions, proves it.

July 16th 1951, Festival of Great Britain.

Honoured to form a large orchestra with strings to play at the Royal Festival Hall.
Leader Reginald Leopold and featuring Sidney Katz with Arthur Greenslade (pno), Bert Courtley, Leslie (Jiver) Hutchinson, Terry Lewis, Bill Sowerby, Jack Thirwell (back row); Alfie Noakes, Fred Mercer Johnny Keating, Jack Botterill, Jock Bain (front row).

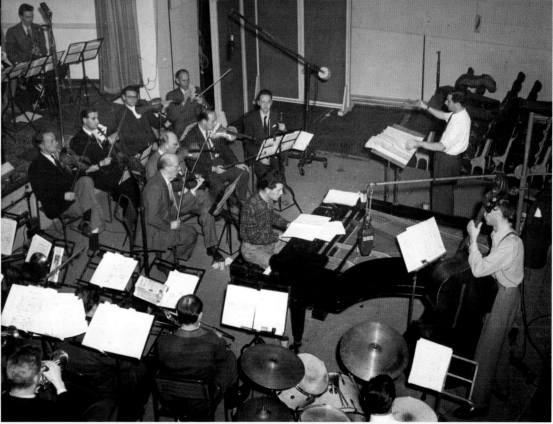

Another view of the orchestra.

In Selmer's music store in Charing Cross Road, London.
Discussing arrangements with Benny Goodman for a forthcoming tour of the UK .

26

Give Me A Dream

To be able to play with the great Satchmo and Billy Kyle.
Here's the dream come true!

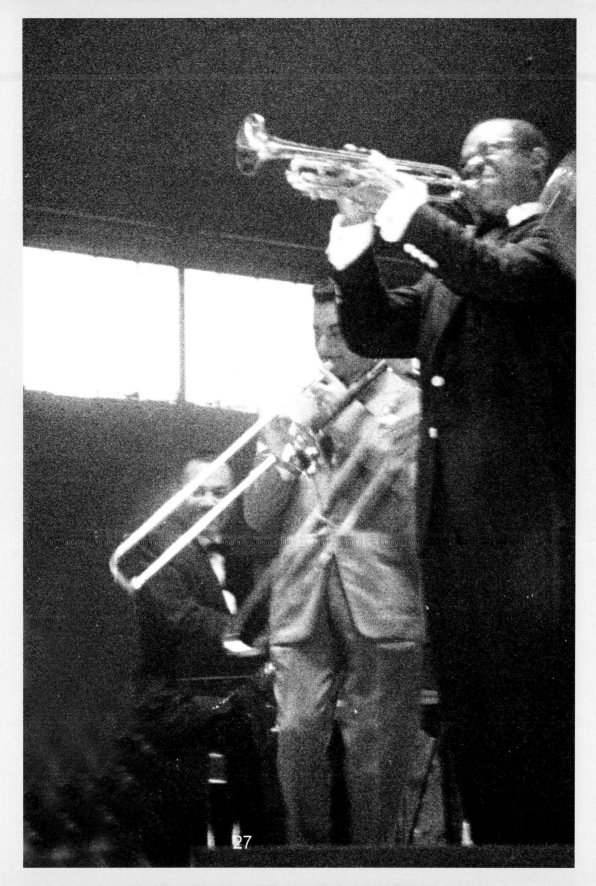

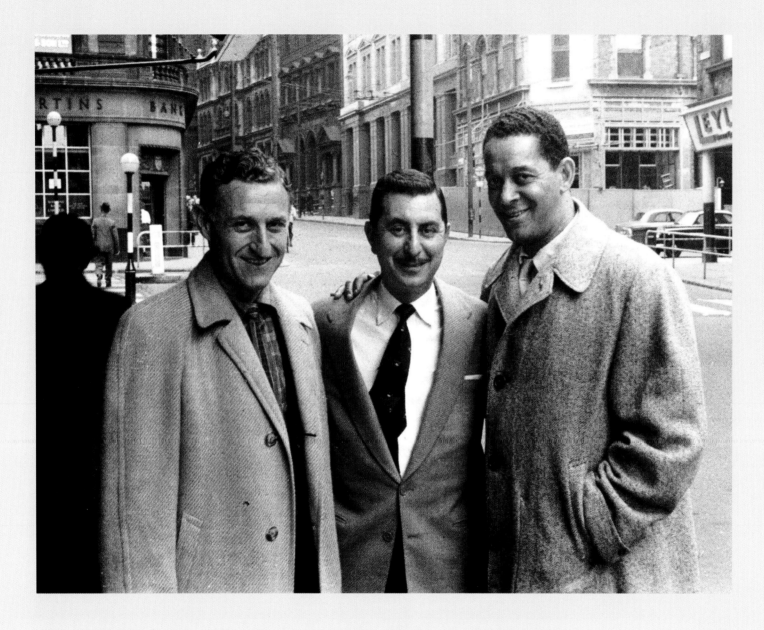

Jack Lesburg (bs) and Trummy Young (tbn). Glasgow, Scotland.

First American Tour, New Jersey, March 1956.

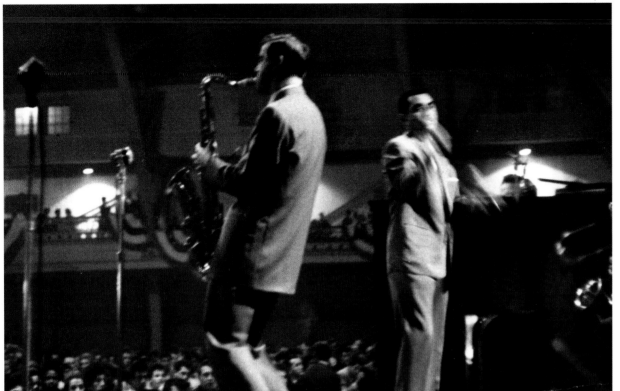

This was an exchange tour for Lionel Hampton's band coming to the UK. The exchange was arranged by Vic and Kenton. On the tour, Tommy Whittle (l) was a guest on tenor.

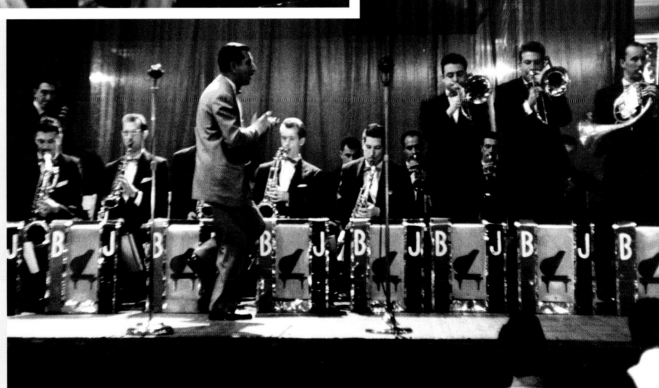

The orchestra borrowed Buddy Johnson's music stands. Fred Crossman featured on french horn.

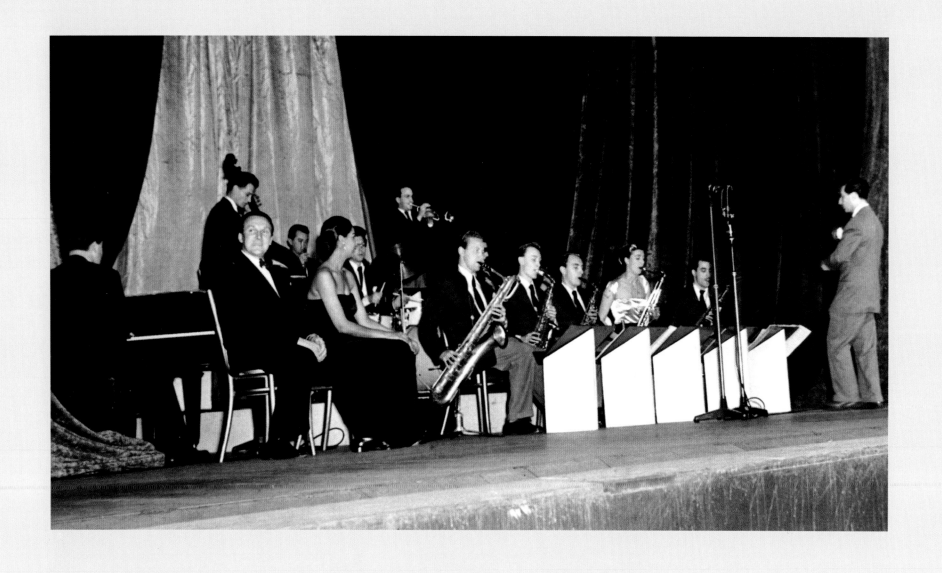

Concert in Oct 1951.
Denny Dennis, Marion Williams (v), Clem Bernard (pno), Martin Gilboy (bs), Peter Coleman (drs),
Bert Courtley, Bill Sowerby, Pete Winslow, Norman McGaskill (tpts). Johnny Keating, Ralph Jenner, (tbns)
Jimmy Simmons, Derek Humble, Ronnie Chamberlain, Kathy Stobart, Danny Moss, (saxes l to r).

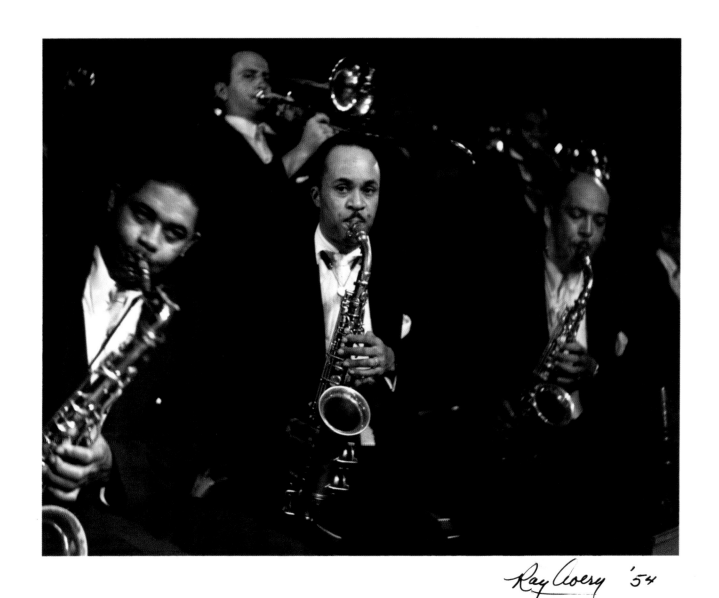

Ray Avery '54

During 1954, Johnny Mandel joined the trombone section of the Count Basie Band. This rare picture hangs in Johnny's studio. When I asked him for a copy, he got Ray Avery to send one to me and now we can all share the moment.

Royal Festival Hall 9th Jan. 1955

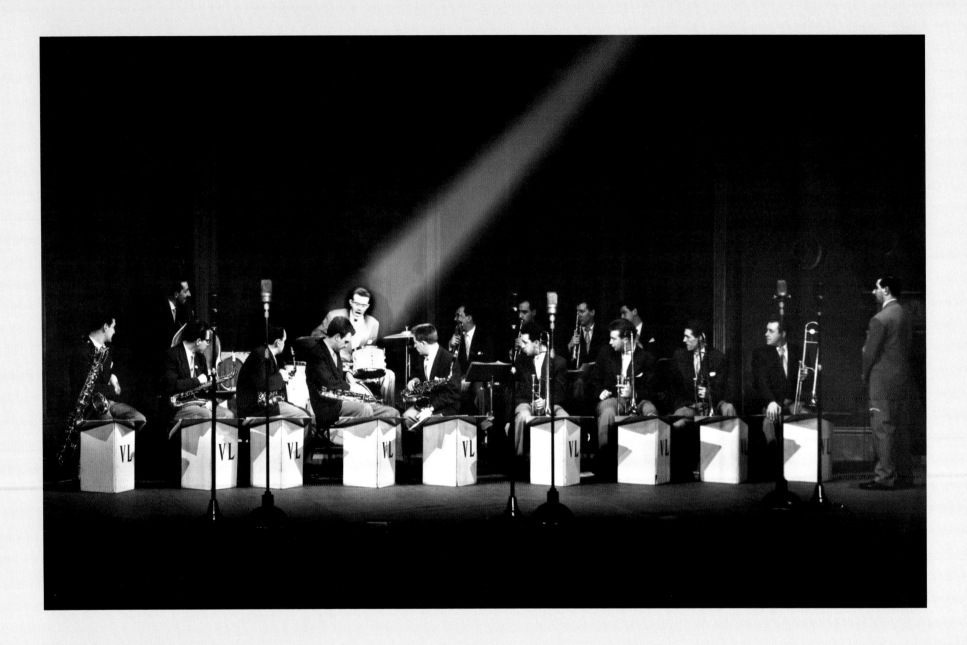

Featuring Andy Whilte on drums.
Ronnie Chamberlain, Bernard Allen, Brian Gray, Howard Morgan, Brian Rodgerson (saxes)
Johnny Watson, Andy Wilson, Rusty Hurran, Alec Gould (tbns)
Johnny Brown, Ronnie Baker, Dave Loban, Trevor Lannigan (tpts)
Red Mitchell (pno), Len Edwards (bs).

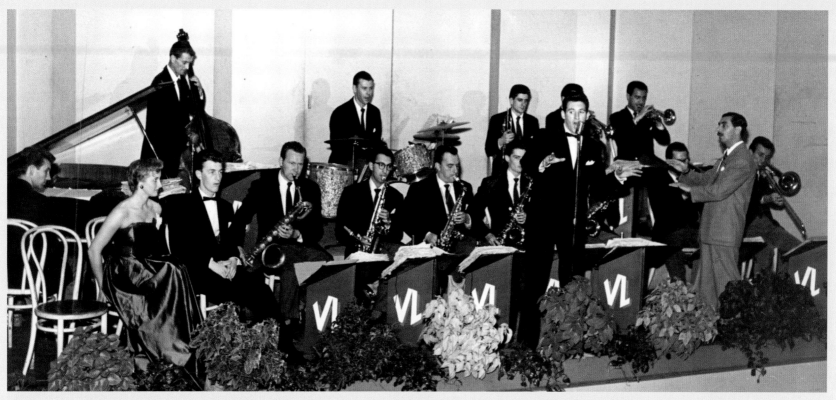

Dean Raymond singing, while Jeri Carson and Roy Garnett sit waiting their turn (1954).
Vic Ash (seated below drummer).

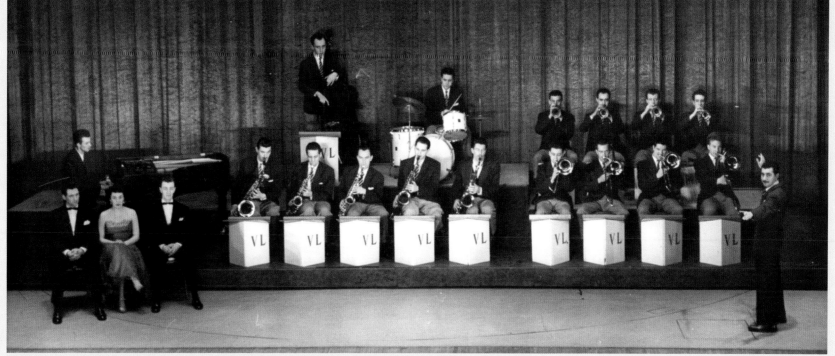

Picture taken at the London Palladium in 1955.

Stan Kenton Orchestra, Alhambra, Paris, 1956.

Included in this rare photo is Lucky Thompson (bar) for the first time, Lennie Niehaus, Bill Perkins and British sax player Don Rendell. Third trombone is previously indisposed Bob Fitzpatrick and fourth is Carl Fontana (leaning forward).

Bob Fitzpatrick was taken ill just before the performance. Stan asked me to take the chair in his place. A wonderful memorable moment and career highlight! (Photo Jean-Pierre Leloir)

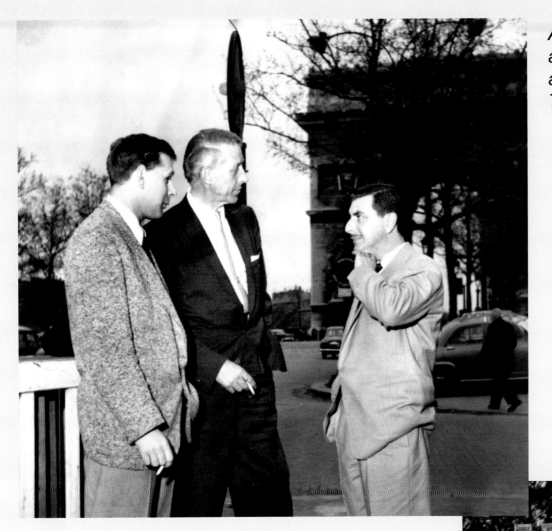

After the Alhambra concert, the French Press asked me to take Stan and Don Rendell on a tour of Paris.
This shot was taken in front of the Arc de Triomphe.

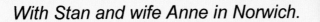

With Stan and wife Anne in Norwich.

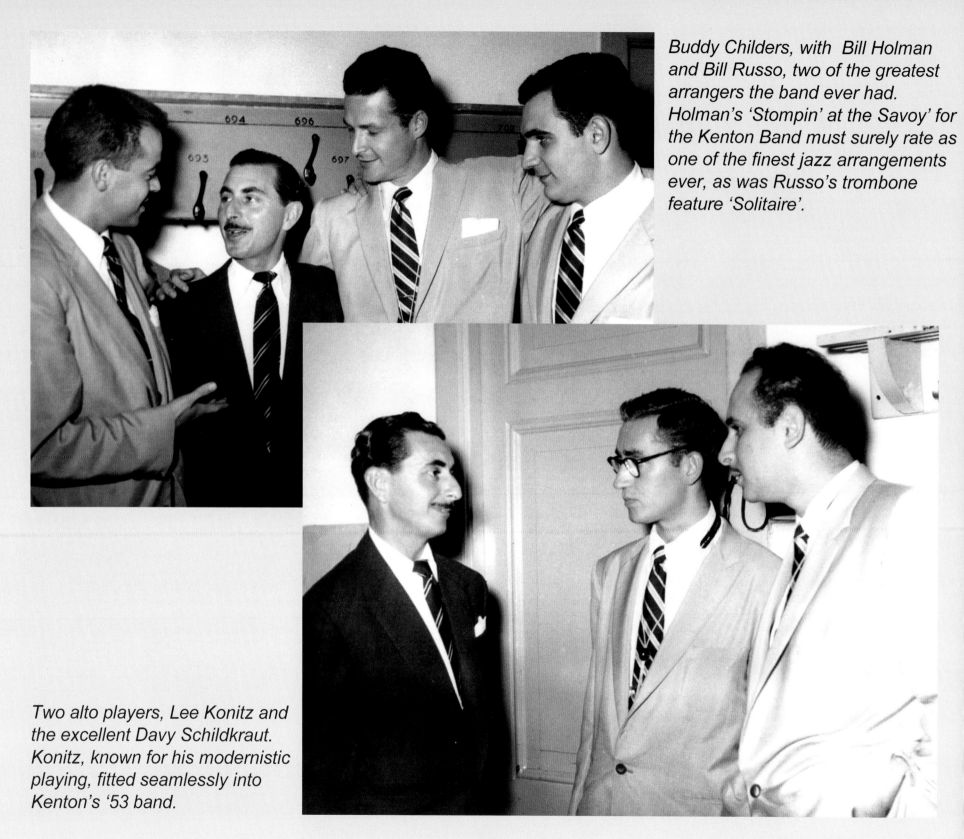

Buddy Childers, with Bill Holman and Bill Russo, two of the greatest arrangers the band ever had. Holman's 'Stompin' at the Savoy' for the Kenton Band must surely rate as one of the finest jazz arrangements ever, as was Russo's trombone feature 'Solitaire'.

Two alto players, Lee Konitz and the excellent Davy Schildkraut. Konitz, known for his modernistic playing, fitted seamlessly into Kenton's '53 band.

Concert Theatre Brussels, Belgium, 1956.

With (l to r) Carl Fontana, Lennie Niehaus, Spencer Sinatra, Ed Leddy, Sam Noto, Vinny Tano, Bill Perkins.

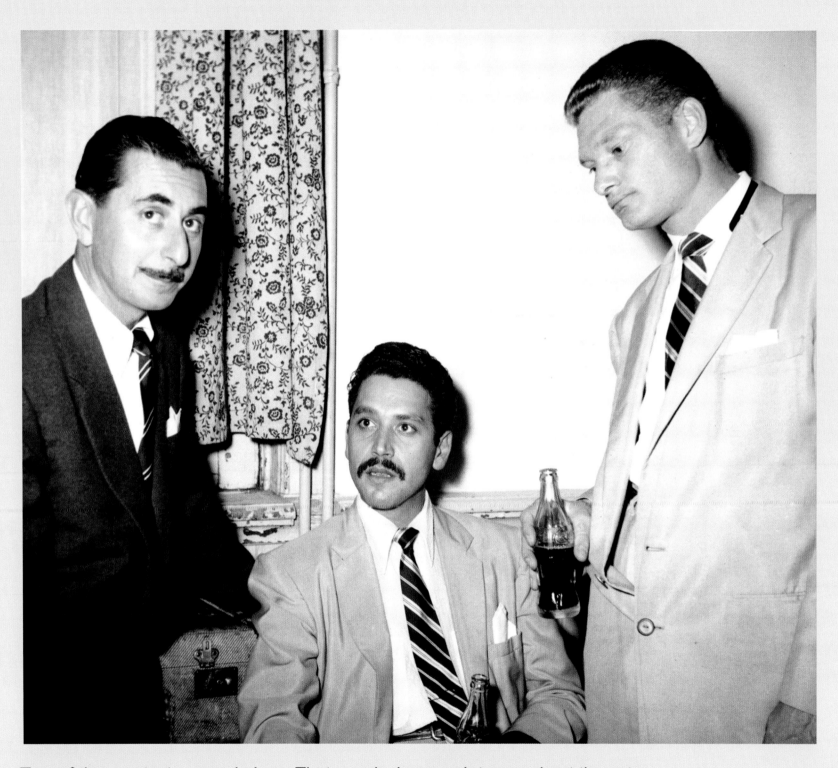

Two of the greatest names in jazz. That, surely, is enough to say about these two.
Frank Rossolino (tbn) and Zoot Sims (tnr) in the Amsterdam Concertegbouw '53. Photo Press-Art Studio

38

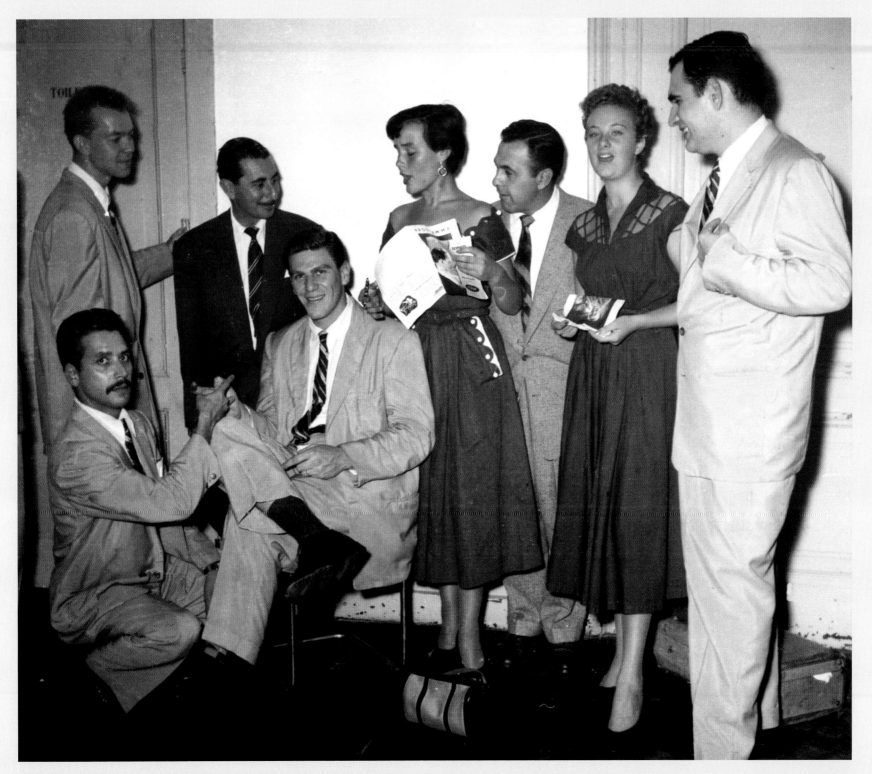

Buddy Childers, George Morte (Stan's road manager) Bill Russo, Frank Rossolino and Stan Levey (seated), taken on the Kenton tour in Brussels.

Dave Schildkraut, Zoot Sims, Stan Kenton, Fred Fox, owner of the Brussels night club. Bill Holman, June Christy, Johnny Dankworth - along for the ride (sitting).

Stan checks over the score at a session with the Royal Philharmonic Orchestra.

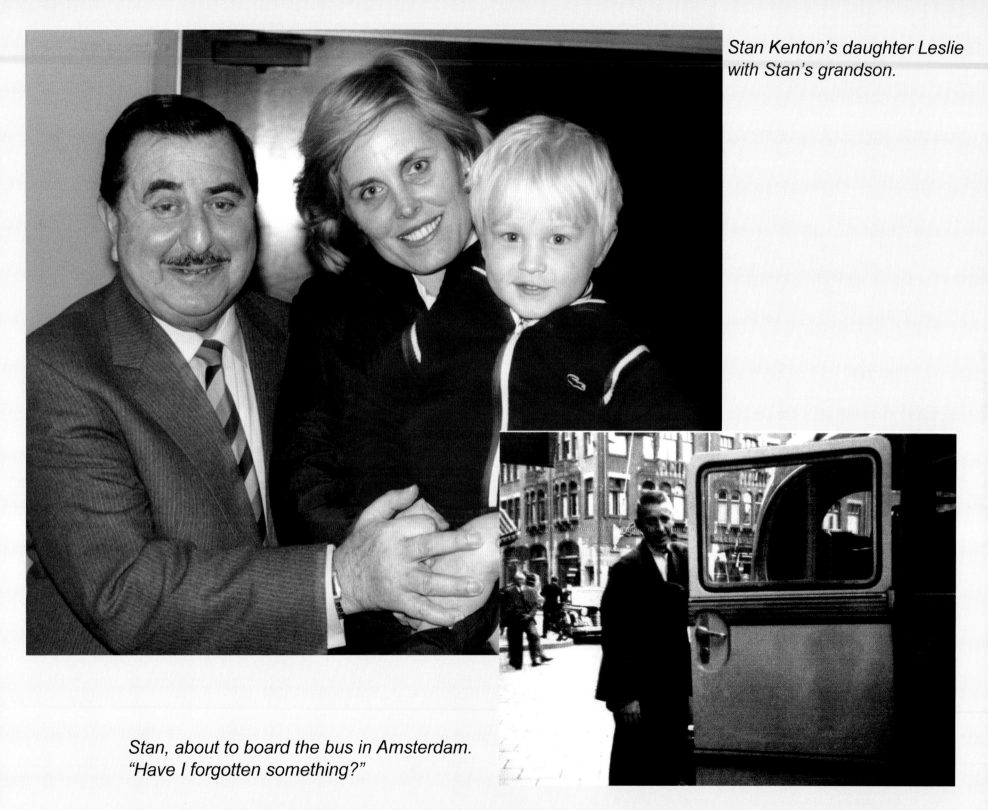

Stan Kenton's daughter Leslie with Stan's grandson.

Stan, about to board the bus in Amsterdam. "Have I forgotten something?"

41

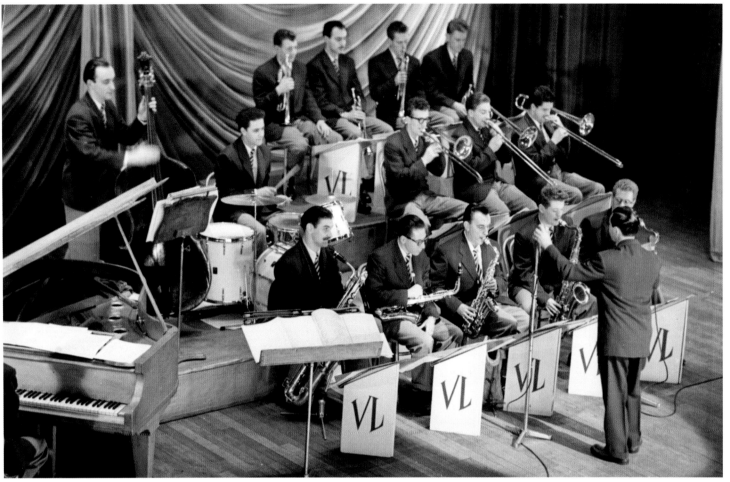

1954 Band
Featuring
Tubby Hayes (tnr).

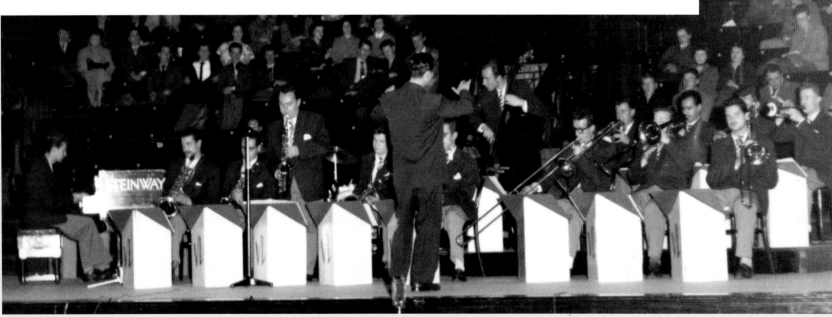

The regular band at Usher Hall, Edinburgh, 1954.

Vic Lewis Orchestra 1954

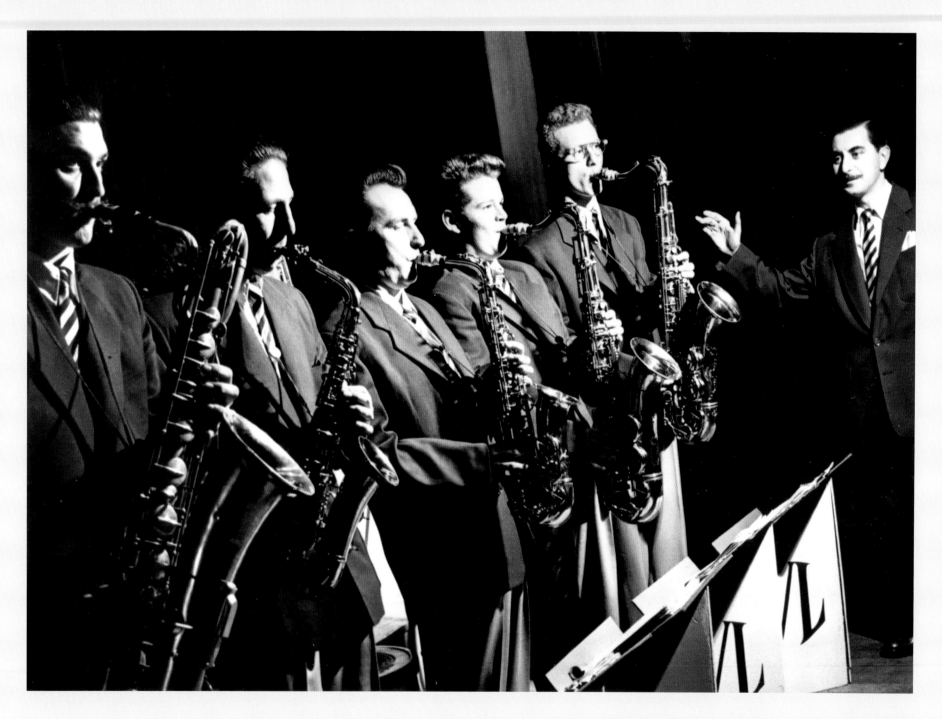

(l to r) Brian Rodgerson, Bernard Allen, Ronnie Chamberlain, Tubby Hayes, Les Wigfield.

South Africa 1955.

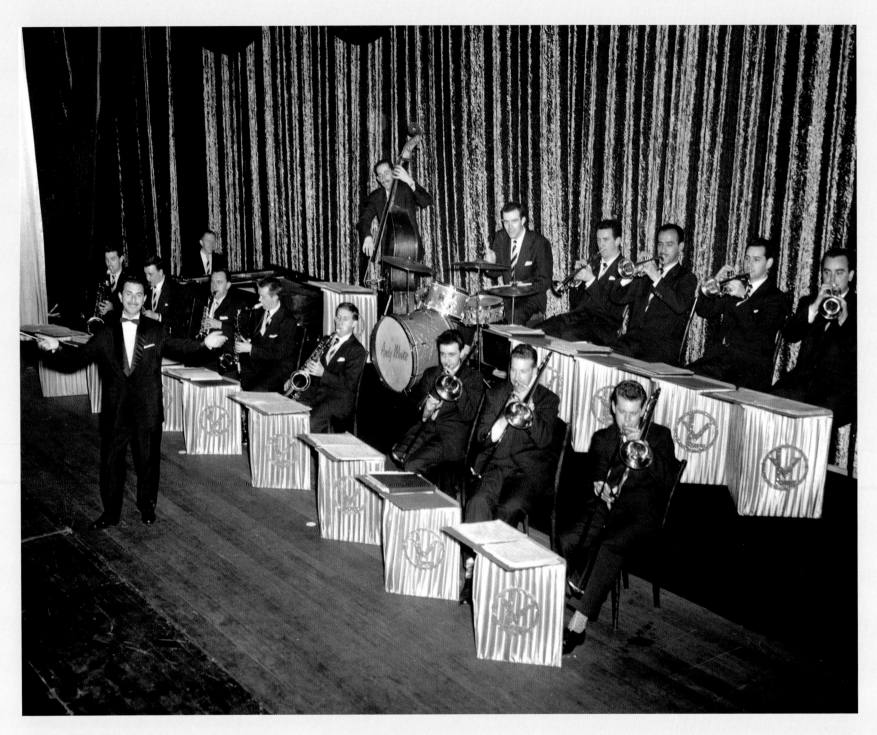

Royalty Theatre, Johannesburg.

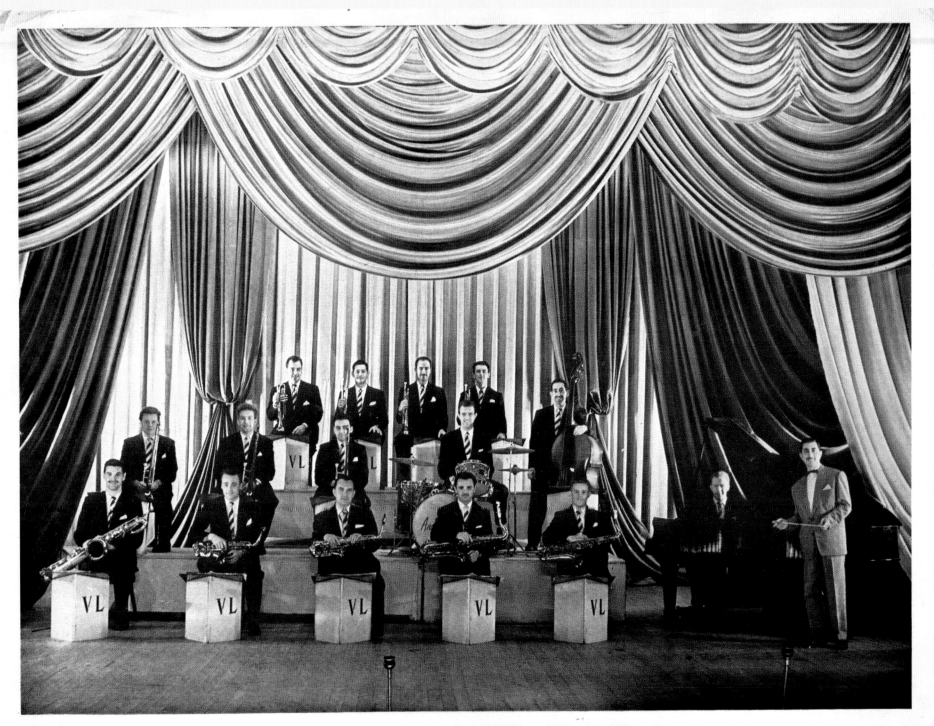

VIC LEWIS AND HIS ORCHESTRA

The orchestra at a broadcast in July 1955. During this period the orchestra was honoured to appear at the Royal Variety Show, Victoria Palace, London. (Promo Photo).

The March 1956 Orchestra

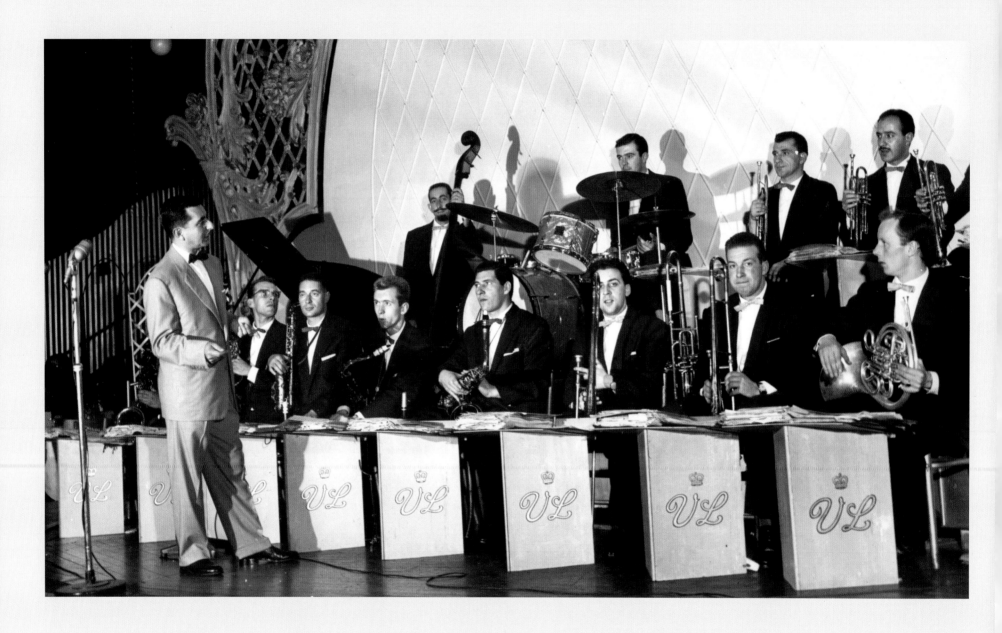

*(Colin Bradfield (third from left) replaced Ronnie Chamberlain,
who had left after eleven years with the orchestra).*

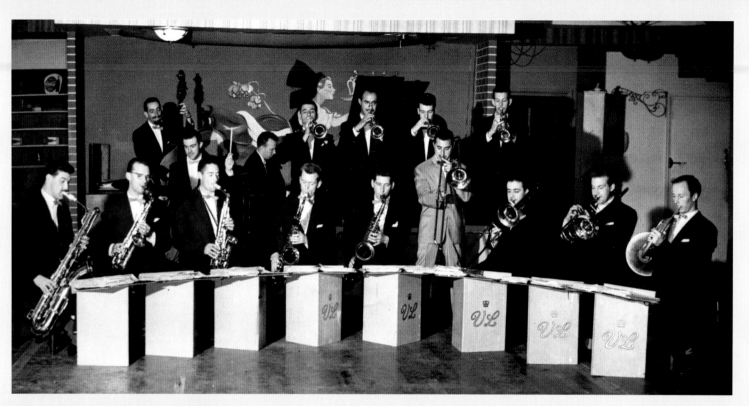

First band to tour the USA in 1956.

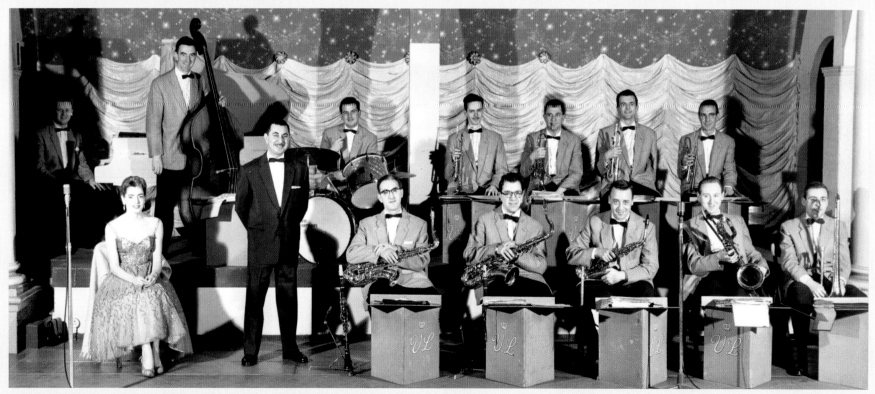

Unusual photo with Harry Klein (bar) (2nd. from right), Irma Logan (v) and Kenny Wheeler (tpt) (4th from left top row).

British Bandleaders honour Satchmo.

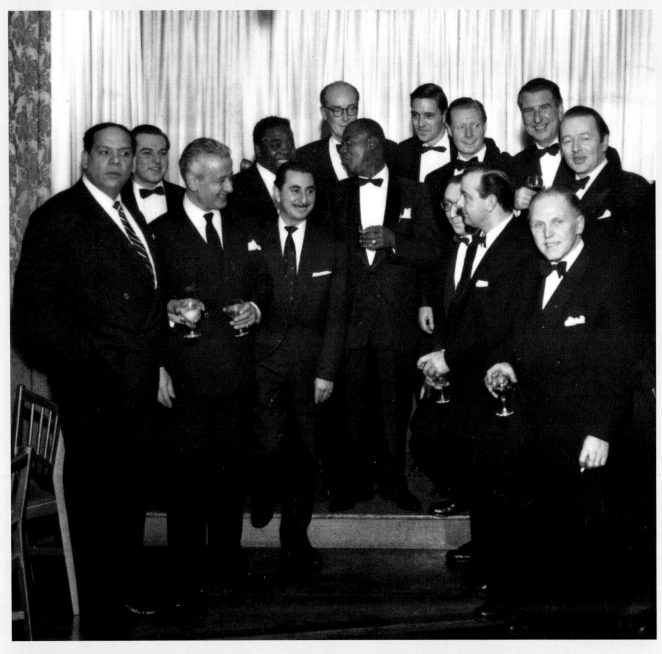

A meeting of British Bandleaders to honour Louis Armstrong (1955 or 56).
(l to r):- Edmundo Ross, Dick Katz, Geraldo, Jiver Hutchinson (behind Vic),
Buddy Featherstonehaugh (behind Louis), Louis Armstrong, Jack Parnell,
Cyril Stapleton, Laurie Gold, Kenny Baker (in profile), Ronnie Aldrich,
Humphrey Lyttelton, Billy Tennant.

Music parlour. Shot by Vic at Stan's home in Alta Drive, Beverly Hills.

Tribute to Stan on the Hollywood Mile.

49

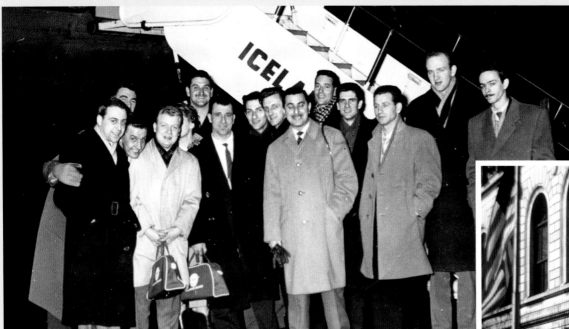

Second tour of America. Stopover in Iceland.
Dicky McPherson, Joe McIntyre, Al Spooner,
Kenny Wheeler, Alec Gould, Colin Bradfield,
Ronnie Baker, Bobby Wellins,
Duncan Lamont, Brian Rodgerson,
Jerry Butler, Bill Stark, Bobby Orr,
Irma Logan. (combined in both pics)

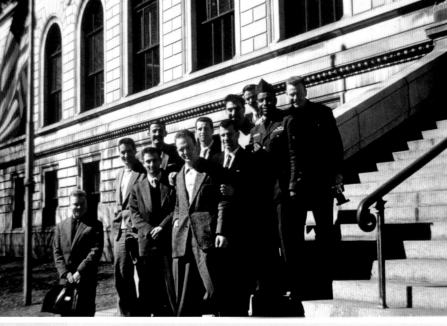

Pictured on steps of the Government Building,
Philadelphia.

Third American Tour 16th Feb 1959.
Alec Gould,Irma Logan, Harry Hall, Bill Metcalfe,
Vic Ash (glasses), Bill Stark, Kenny Wheeler,
Roy East, Dickie McPherson, Brian Rodgerson,
Bev Ingermales, Dudley Moore, Jim Poole,
Derek Hogg.

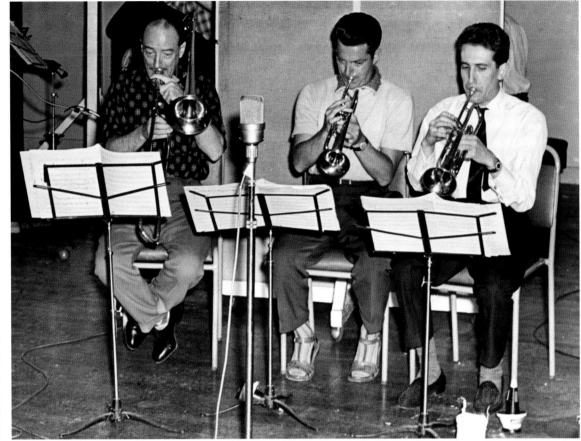

(l to r) George Chisholm, Eddie Blair, Les Condon.

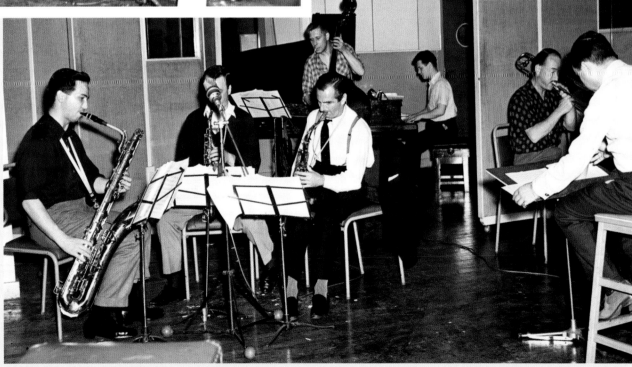

Conducting an all star recording
group with Ronnie Ross (bar),
Roy East (alt),
Ronnie Scott (tnr),
Bill Sutcliffe (bs),
Alan Branscombe (pno),
George Chisholm (tbn).

The '60s

The last date the band played in the US was at Birdland in New York, in April 1960, where many illustrious jazz stars and show business personalities turned out to hear our farewell performance. Joining the management and agency side of the business (covered in my earlier book 'Music and Maiden Overs', written with Tony Barrow) I also continued to record – initially with Nelson Riddle and then Tubby Hayes, Ronnie Scott and others, as seen in the succeeding pages. A classical period followed during which I conducted the Royal Philharmonic Orchestra and made nine albums with them.

Leonard Feather, George Chisholm, Ronnie Ross (bar) and Roy East (alt).

USA touring band in Bridgeport CT. 1960.
Ray Dempsey, Terry Shannon, Shirley Moore, Roy East, Arthur Watts, Gordon Turnbull, Jimmy Deuchar, Keith Christie, Vic Ash, Art Elefson, Allan Ganley, Ronnie Ross, Leon Calvert.
Photo Vic Lewis.

With Carmen McRae and journalist Tony Hall.

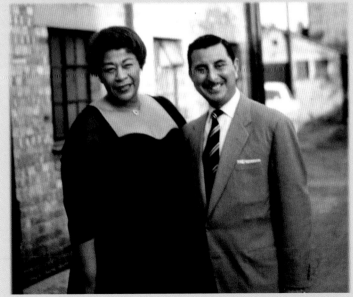

June Christy (l) and friend.

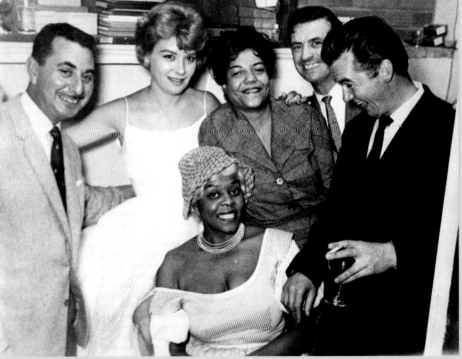

With the wonderful Ella Fitzgerald at the
New Victoria, Hammersmith 1960's.

Helen Merrill, unidentified lady pianist,
Bill Manning (owner of Britain's number one Jazz club at
the time- The Blue Lagoon), Dil Jones
and Dinah Washington (seated).

Atmospheric 'Lewis' photo. Back stage with the Four Freshmen. In Germany in 1963.

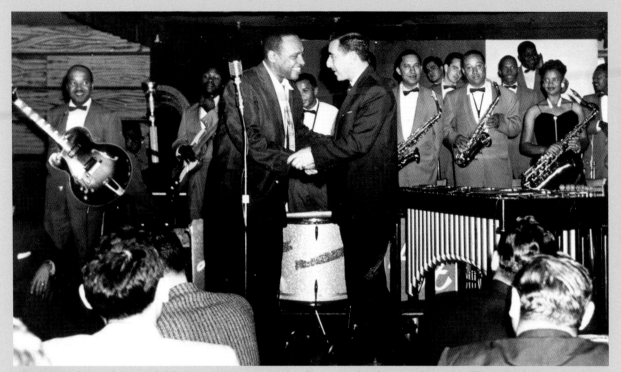

Greeted by Lionel Hampton and his Band during a Lewis Tour of the USA.

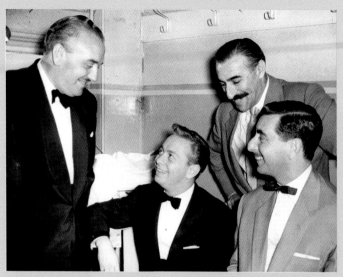

Ted Heath, Mel Torme and Sam Costa

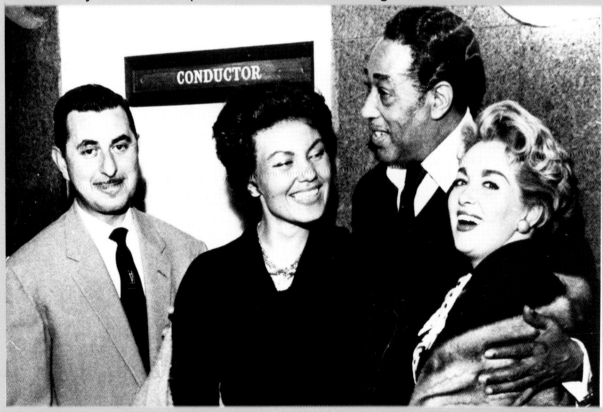

Cleo Laine and Marion Ryan get a cuddle from Duke Ellington 1960's

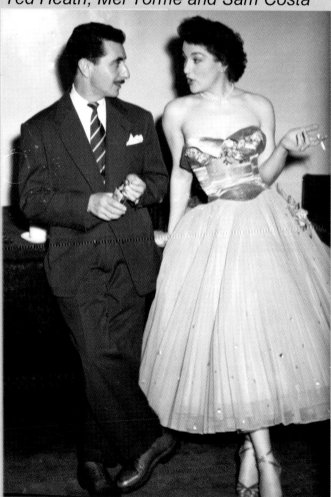

Annie Ross, backstage at the Albert Hall.

Farewell concert at Birdland New York. April 11th 1960.
Band comprised:- Dicky McPherson, Jimmy Deuchar, Leon Calvert, Gordon Turnbull (tpts) Keith Christie (tbn),
Roy East, Vic Ash, Art Elefson, Ronnie Ross (saxes), Terry Shannon (pno), Ray Dempsey (gtr), Arthur Watts (bs),
Allan Ganley (drs) and Shirley Moore (vcl). (Photo Robert Parent).

The Bossanova Album,'Home and Away'.The 'Away' session in Hollywood.

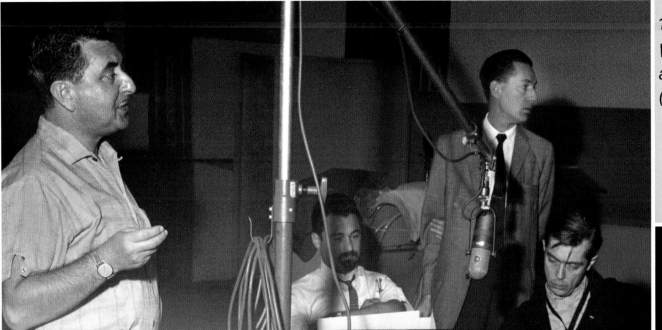

18th Jan 1963
With Shorty Rogers, Leonard Feather
and Bud Shank.
(The Home Session was in London)

Laurindo Almeida, Al Hendrickson
and Don Bagley

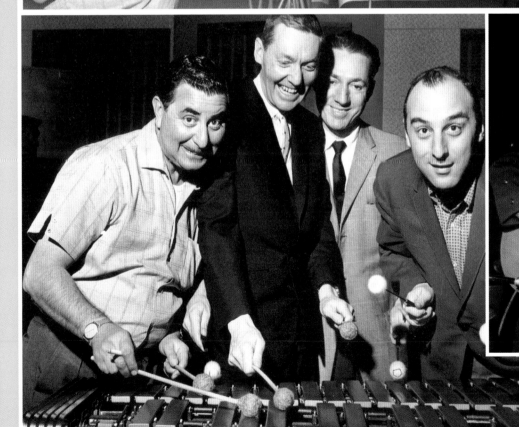

With writers Howard Lucraft, Leonard Feather
and Victor Feldman (vbs)

Signed Memories

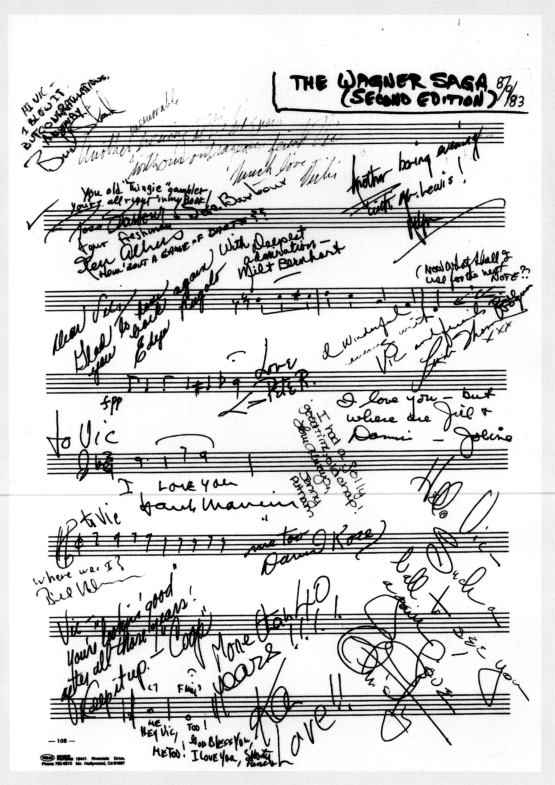

This all started as a joke at the Wagners' house. Bill was manager of the Four Freshmen, and he got those attending the party to sign a guest book. In the end the book was presented to me and it started off the fad of obtaining more signatures of stars to go with the many autographed photos I had previously been given.

Drawing on the back of a photo. From Dizzy Gillespie, 1988.

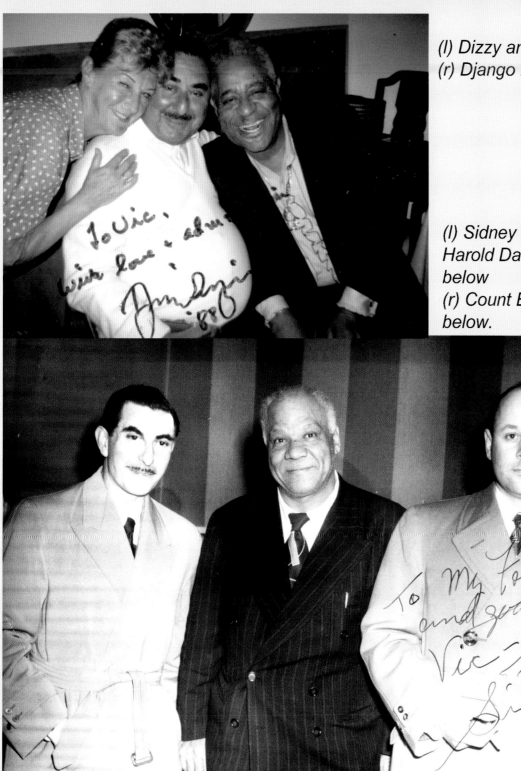

(l) Dizzy and Jill.
(r) Django Reinhardt

(l) Sidney Bechet
Harold Davison
below
(r) Count Basie
below.

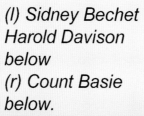

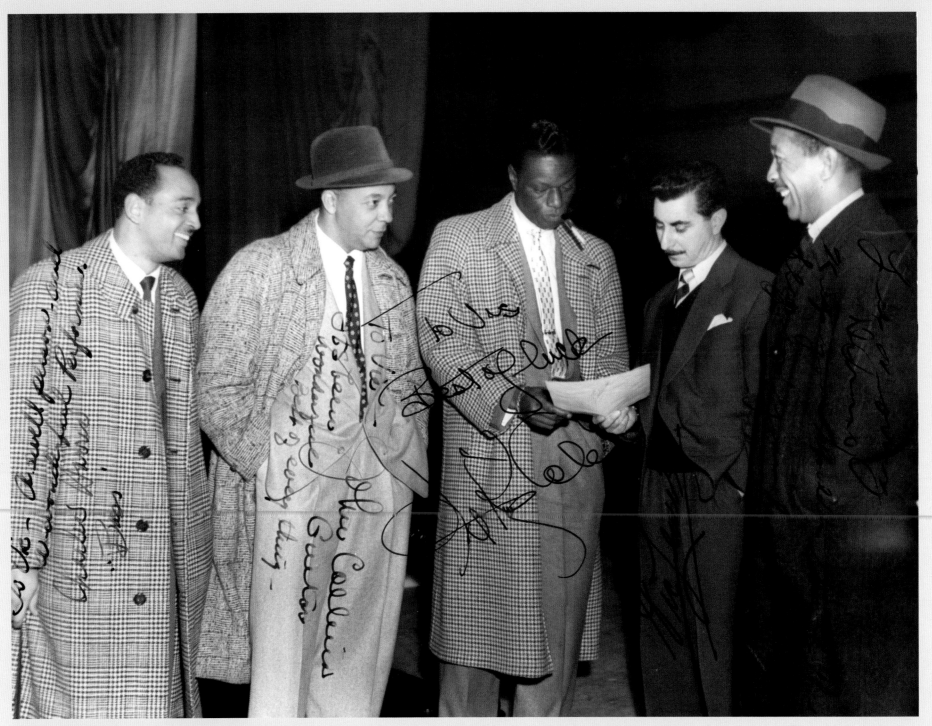

The Vic Lewis Orchestra accompanied Nat Cole on several British tours and on some of the titles Cole played piano with the band's rhythm section.
Pictured here are Charlie Harris (bs), John Collins (gtr), Nat Cole and Lee Young (drs).
Recordings were made at Glasgow and Blackpool but never issued.

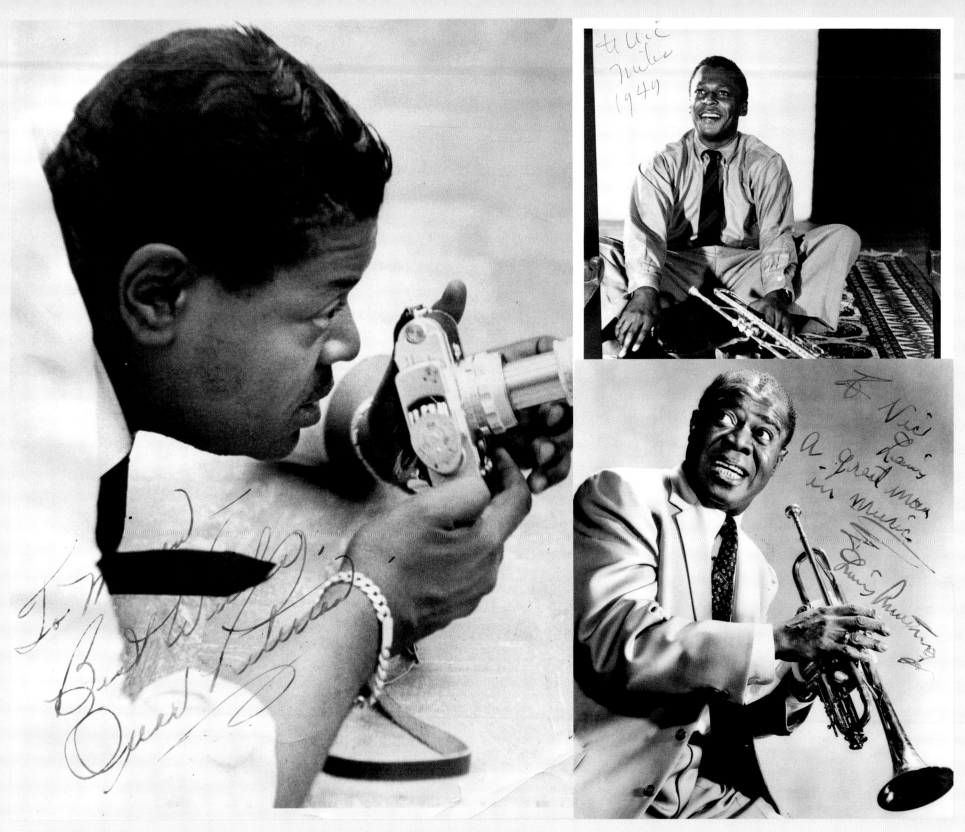

Oscar Peterson, a rare Miles Davis signature and Louis Armstrong.

61

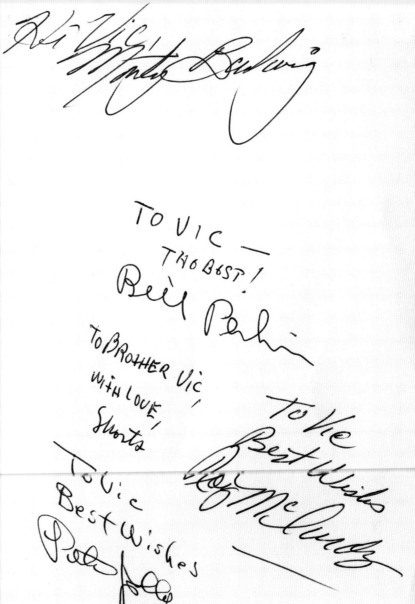

Birthday card from: Bill Holman, Milt Bernhart, Bob Cooper, Conte Condoli, John Clayton, Bud Shank, Jiggs Whigham and daughters Emily and Jenny.

Monty Budwig, Bill Perkins, Shorty Rogers (Shorts) Roy McLurdy, Pete Jolly.
At the Biltmore Hotel Los Angeles 1987.

62

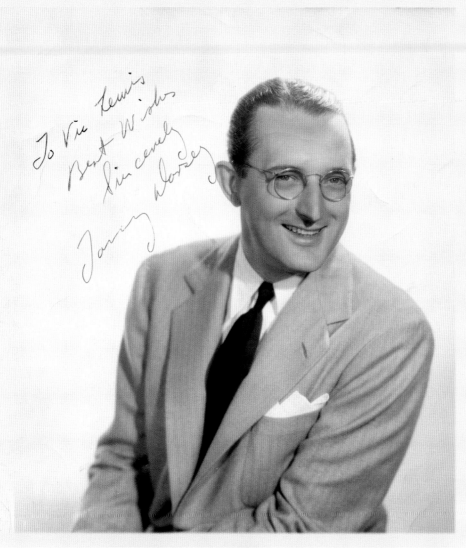

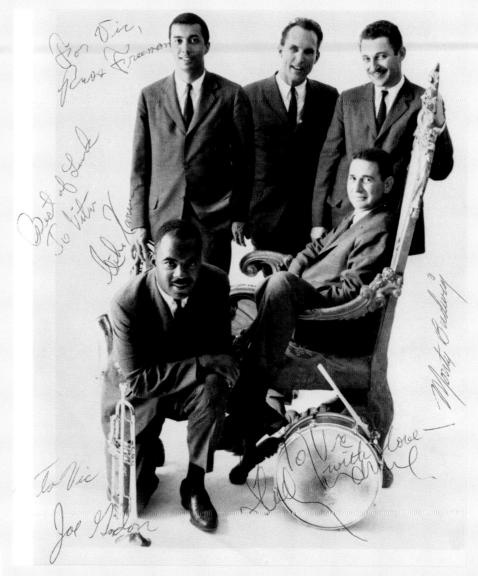

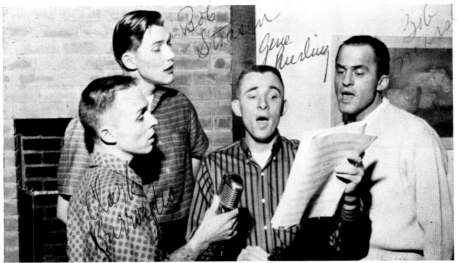

(Top Left) Tommy Dorsey
(Top Right) Shelly Manne Group
(Top) Russ Freeman (pno), Monty Budwig (bs)
Richie Kamuka (sax).
Shelly Manne (Seated) and Joe Gordon (tpt).
(Below Left) The Hi-Los.

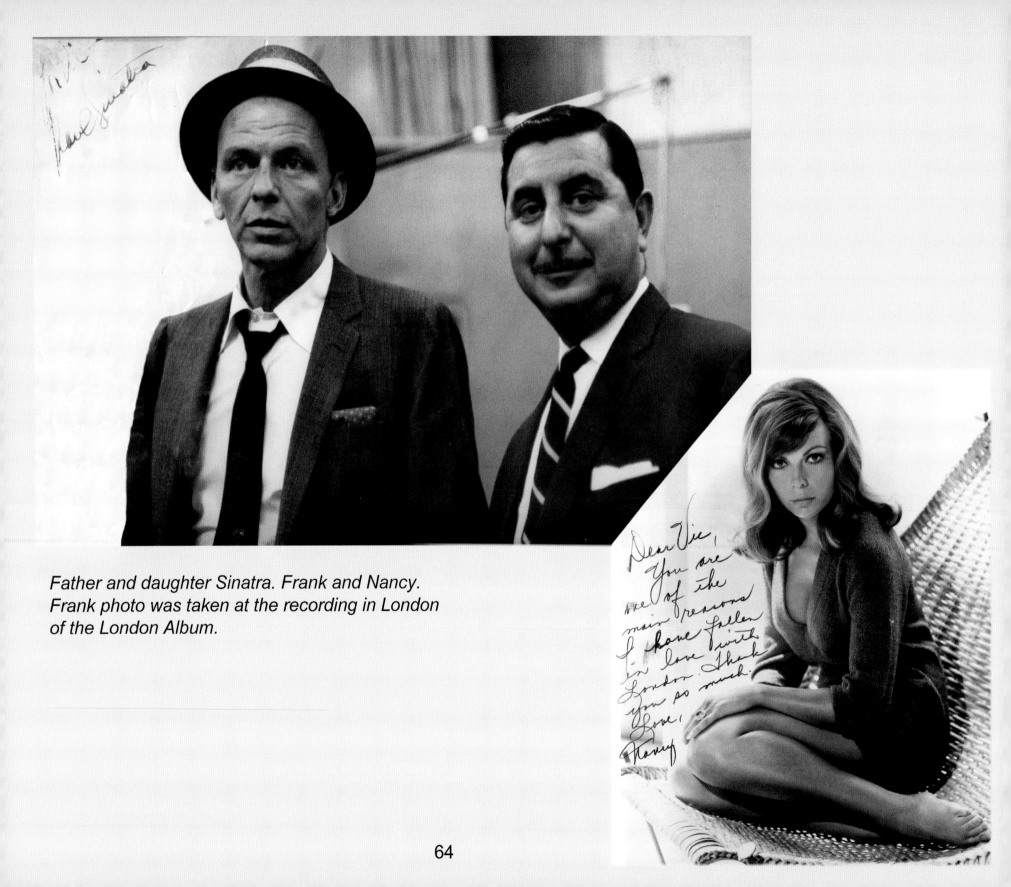

Father and daughter Sinatra. Frank and Nancy.
Frank photo was taken at the recording in London
of the London Album.

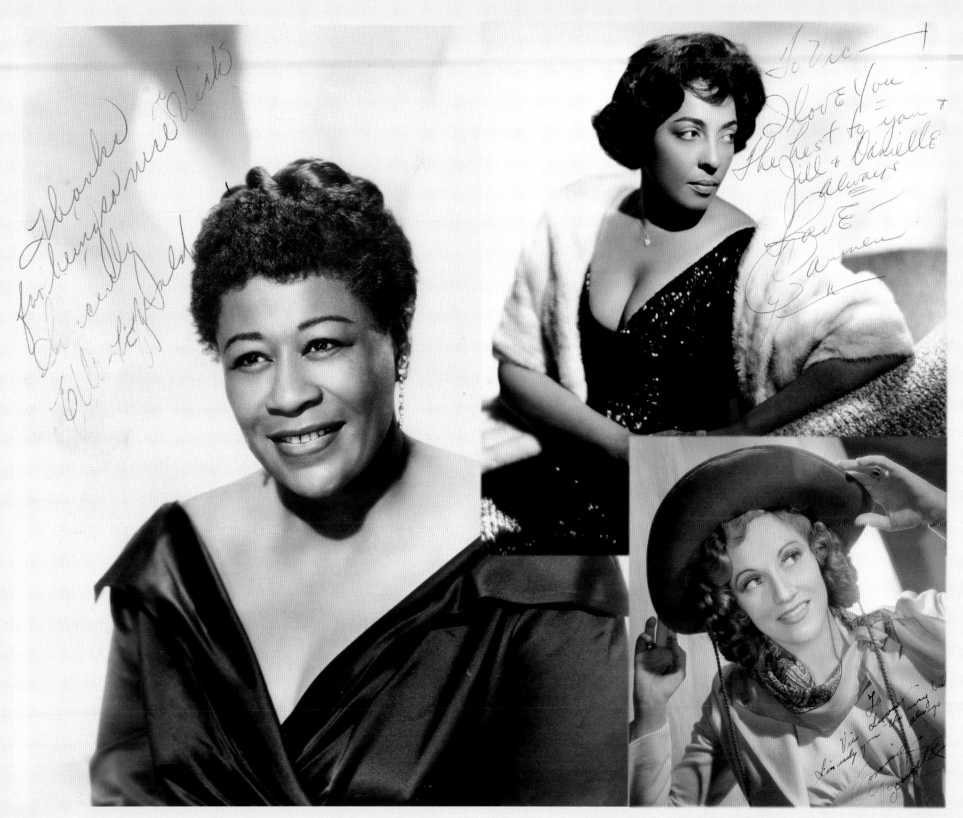

Ella Fitzgerald, Carmen McRae and Connie Boswell.

24 July 96

Dear Vic,

Here is Port Townsend having a ball with a ton of great friends. See you soon,

Love Jiggs!

Hi Vic —
Just hang'in in the Pacific Northwest — came up to play with Bud's sextet.
Hello to any & all
Regards — Jack Nimitz

To Vic —
Good Quene Bess, I guess?
Happy Birthday!
Conte Condoli

Vic — Sizzler's is no more!
We'll have to make a fresh start
Love
Perk

Vic — Happy Birthday, my man!
I'll call you soon
Bud

Another 'card' from Jiggs Whigham, while on the job.

Jiggs Whigham
Jack Nimitz
Conte Condoli
Bill Perkins
Bud Shank.

66

Stan Kenton ORCHESTRA

NO. LA CIENEGA • HOLLYWOOD 46, CALIFORNIA • CRESTVIEW 1-5267

BOB ALLISON, MANAGER

April 10, 1951

Mr. Arthur Frankham
150 Outer Forum
Norris Green
Liverpool 11, England

Dear Arthur:

Just a few lines to acknowledge your enthu-
siastic letter that just arrived. I am glad
you got to visit with Vic Lewis. We all
cherish not only what he has done in England,
but his friendship as well.

No one hopes more than we do to someday visit
England. Thank you again for writing.

Sincerely,

STAN KENTON

SK:jw

"INNOVATIONS IN MODERN MUSIC"

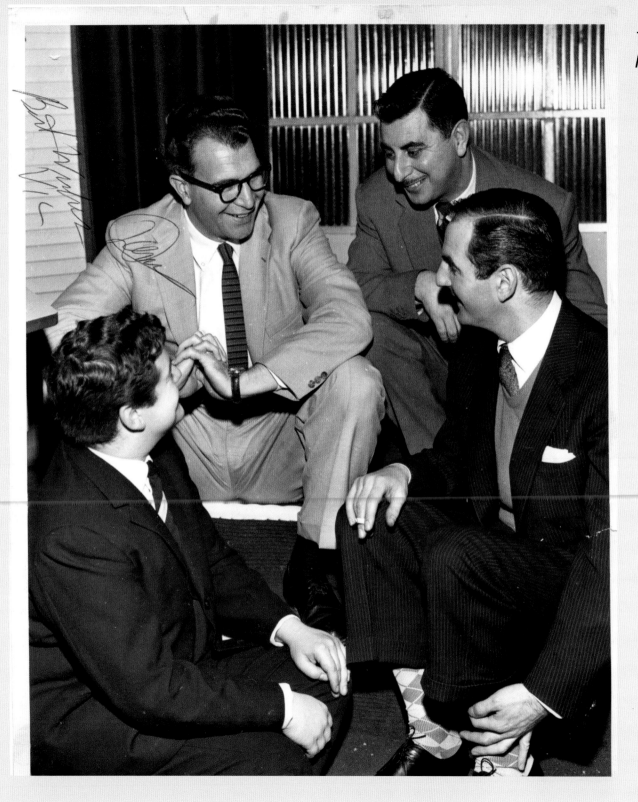

Tubby Hayes, Dave Brubeck, Ronnie Scott

Johnny and Martha Mandel.

Alan & Marilyn Bergman.

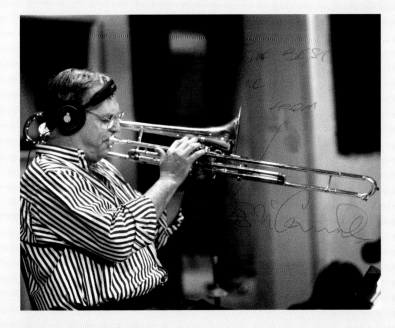

Rob McConnell

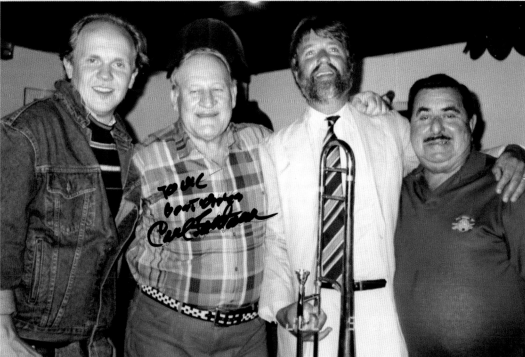

Christian Lindbergh, Carl Fontana and Jiggs Whigham.
(Photo Adrian Korsner, Sound Images)

The Arrangers and Composers

During my life I have been privileged to work with some of the finest musical arrangers of any era. Some have produced scores for my various orchestras, others have worked and played within one or other of my groups.

I list them here in no particular order of merit, although they in my view, constitute a collection of the greatest and most talented musicians that have graced the 20th and early 21st centuries.

As you turn the next pages of this record of my Life in Jazz, each photo carries a brief note, or anecdote, relating to the period in which I encountered these giants of jazz. Nevertheless these brief annotations can only hint at the esteem that I hold for these incredibly talented people and the close personal friendships that developed with many of them.

Ken Thorne	Bob Brookmeyer	Alec Gould
Johnny Keating	Rob Pronk	Jeremy Lubbock
Manny Albam	Robert Farnon	Alan Broadbent
André Previn	Lennie Niehaus	Bill Holman
Christian Jacob	Bill Russo	David Rose
Henry Mancini	Nelson Riddle	Hank Levy
Billy May	Neil Hefti	Marty Paich
Gerry Mulligan	Johnny Mandel	Pete Rugulo
Shorty Rogers	Claus Ogerman	Gene Roland
Johnny Richards	Allyn Ferguson	Alan Bergman
John Clayton	Franklin Marks	

There are many other great musicians, not listed here, who I also hold in the highest esteem.
I have not nor may ever have the opportunity or good fortune to meet them but their music has given me immense pleasure. In a list of great arrangers, they deserve a mention here.
Gil Evans, Eddie Sauter, Bill Finnegan, Claude Thornhill, Gordon Goodwin, Tom Kubis, John Cameron and George Handy (whom I consider to be the best writer of the 1920's to 1950's era) are just a few.

To those I have omitted, I apologise

Discussing 'Jazz and Classics' with Andre Previn, at the Royal Festival Hall. (1970's)

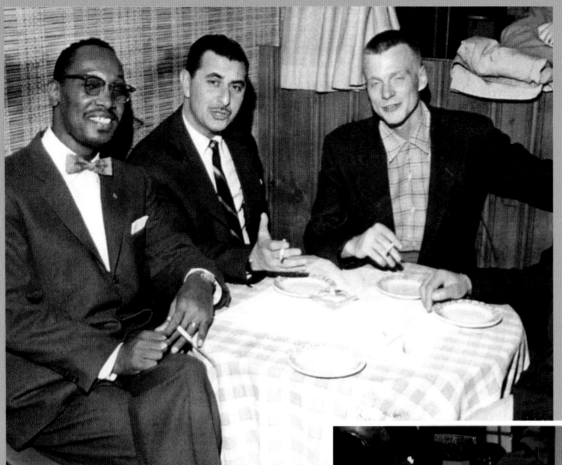

Tadd Dameron (l) and Gerry Mulligan (r) relaxing whilst listening to The Lionel Hampton orchestra.

Breakfast at Newport Beach with Hank Levy who was an important arranger for Stan Kenton.
(Photo Adrian Korsner, Sound Images)

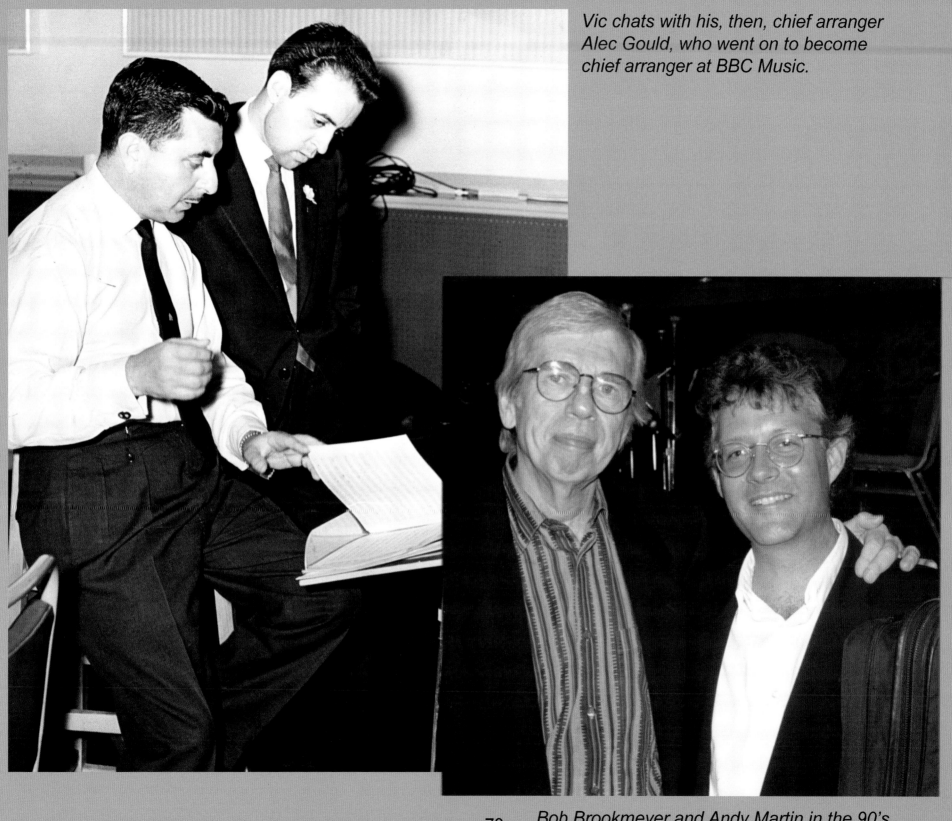

Vic chats with his, then, chief arranger Alec Gould, who went on to become chief arranger at BBC Music.

73 Bob Brookmeyer and Andy Martin in the 90's.

Discussing a score with Pete Rugulo at Grove Studios.

The musicians at the Grove sessions.

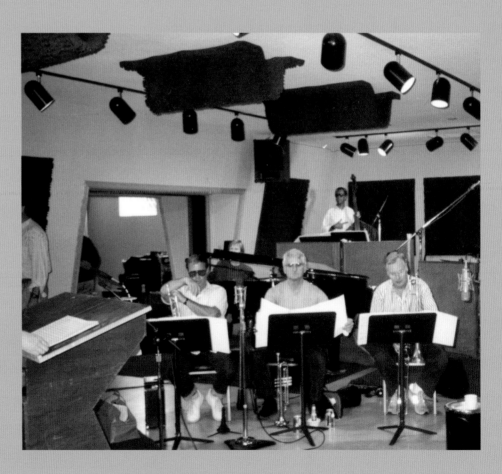

Session at Grove,
Jack Sheldon (tpt), Conte Condoli (tpt),
Rob McConnell (tbn).
Rear, John Clayton (bs).

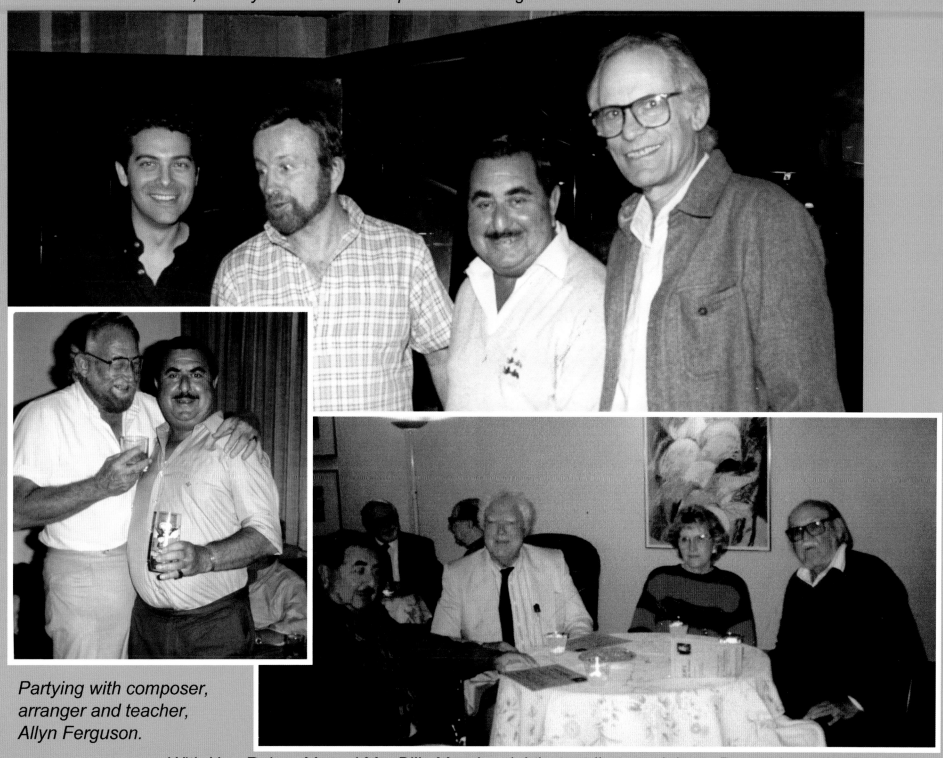

*Recording 'Where Do You Start' at Michael Feinstein's 1st recording session.
With Michael Feinstein, Johnny Mandel and composer Alan Bergman.*

Partying with composer, arranger and teacher, Allyn Ferguson.

With Una Raiser Mr and Mrs Billy May (on right) at a tribute to Johnny Best at La Jolla, San Diego.

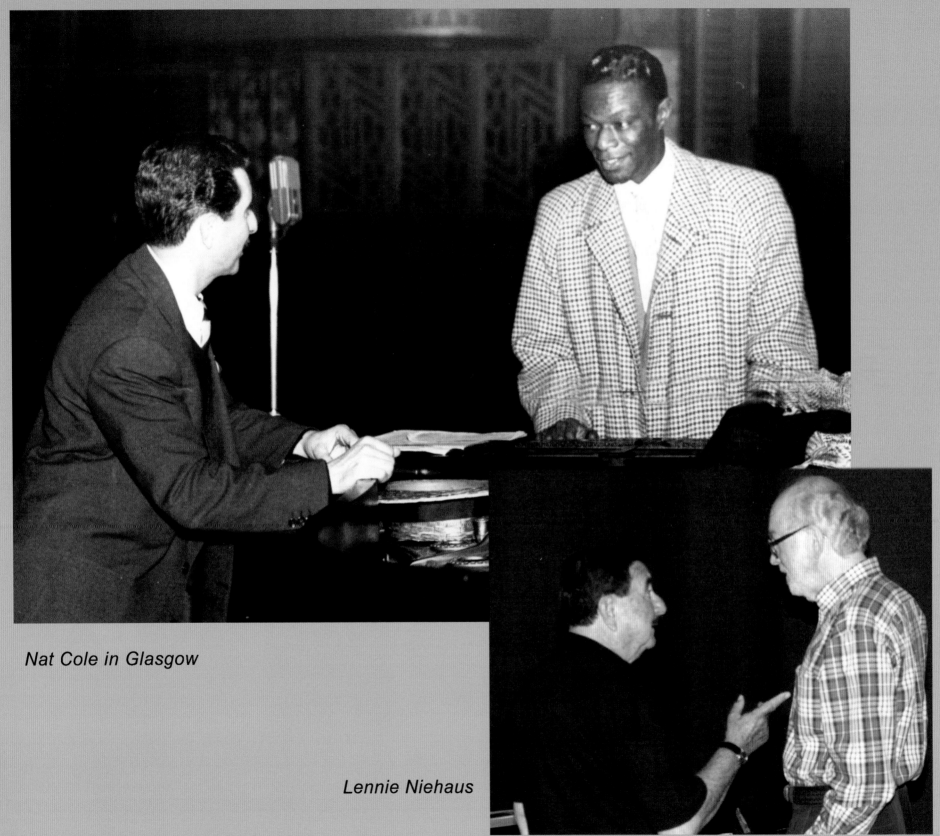

Nat Cole in Glasgow

Lennie Niehaus

76

Massaging Clare Fischer's shoulders after a long session with The Metropole Orchestra in Hilversum.
(Photo Adrian Korsner, Sound Images)

My daughter Danielle with her godfather Nelson Riddle.
We first met with Sinatra in 1960 and stayed close friends until his untimely death.

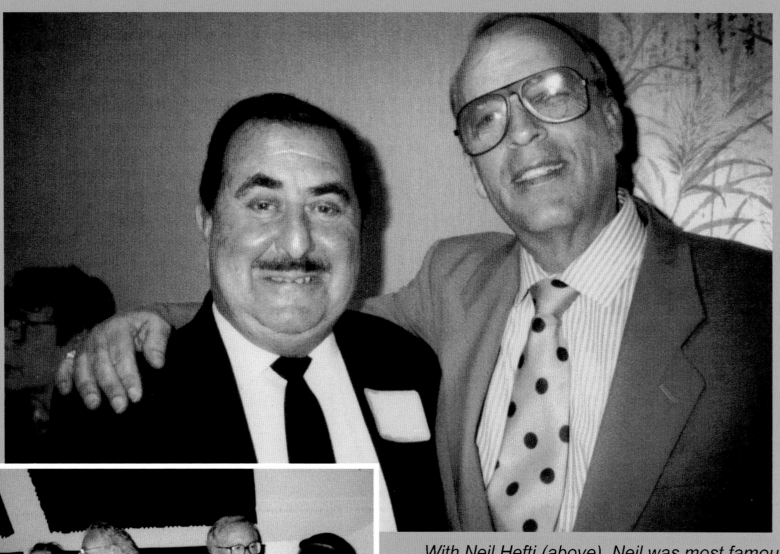

With Neil Hefti (above). Neil was most famous for the record " The Atomic Basie" .
After nearly 40 years of friendship I suggested he do a record of "The Atomic Mr Hefti"!

David Rose (l) pops into Vic's session at AF's studio in L.A. Allyn Ferguson (c) and Pete Rugulo (r)

78

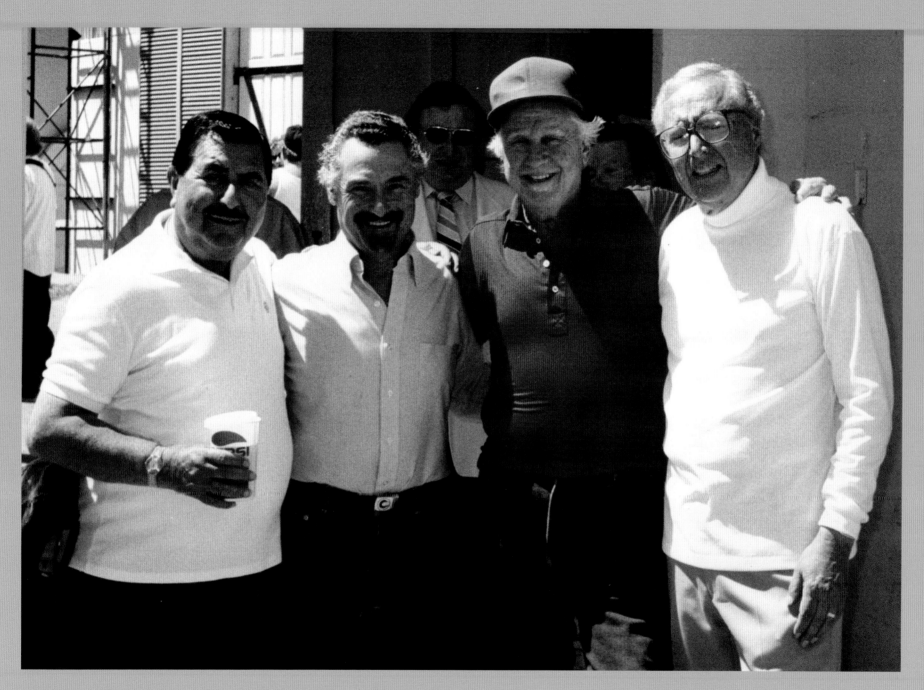

With Shorty Rogers, Marty Paich and Pete Rugulo.
At the Kenton tribute concert, Anson Ford Theatre, Hollywood, 1989.

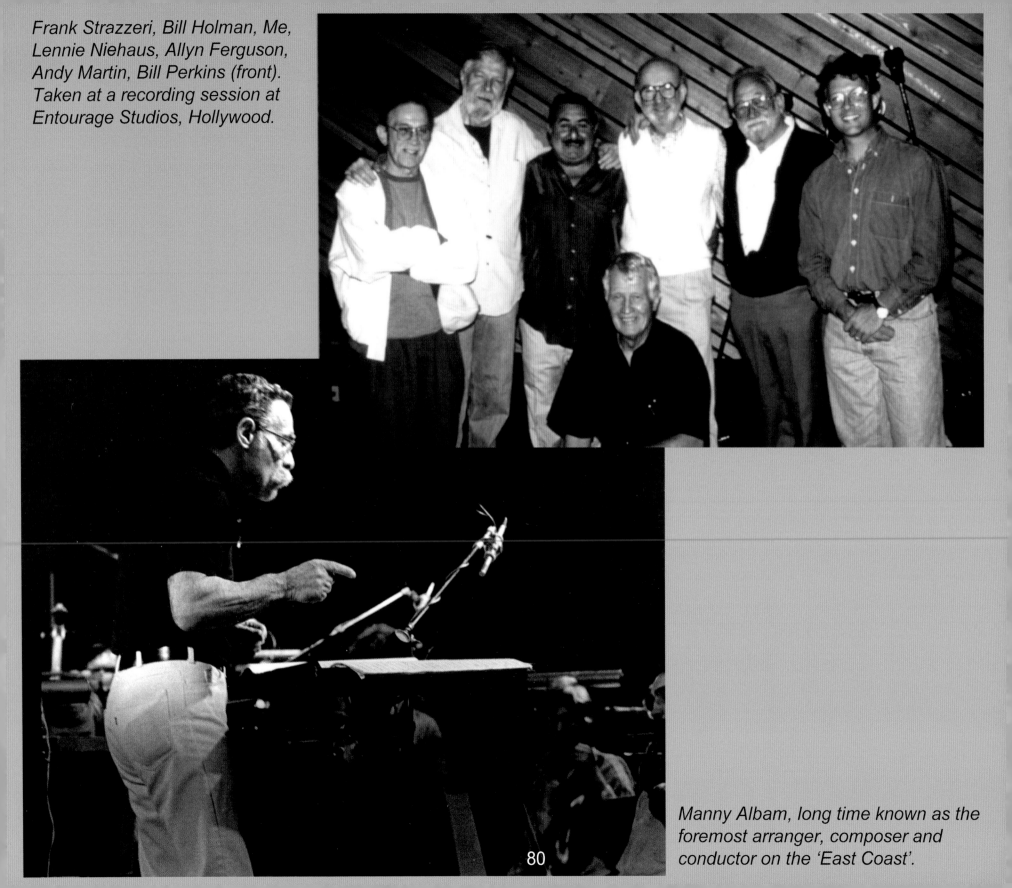

Frank Strazzeri, Bill Holman, Me,
Lennie Niehaus, Allyn Ferguson,
Andy Martin, Bill Perkins (front).
Taken at a recording session at
Entourage Studios, Hollywood.

Manny Albam, long time known as the
foremost arranger, composer and
conductor on the 'East Coast'.

Nelson Riddle with daughters Rosemary, Bettina and Cecily, taken at Malibu 1961.

At the 'Wagner' party with two of the best composers in modern music, Henry Mancini and David Rose (standing).

Tony Bennett recording session. 1971.
Vic produces 'The Very Thought Of You' with Johnny Keating (arr Standing) and featuring Bobby Hackett (tpt).

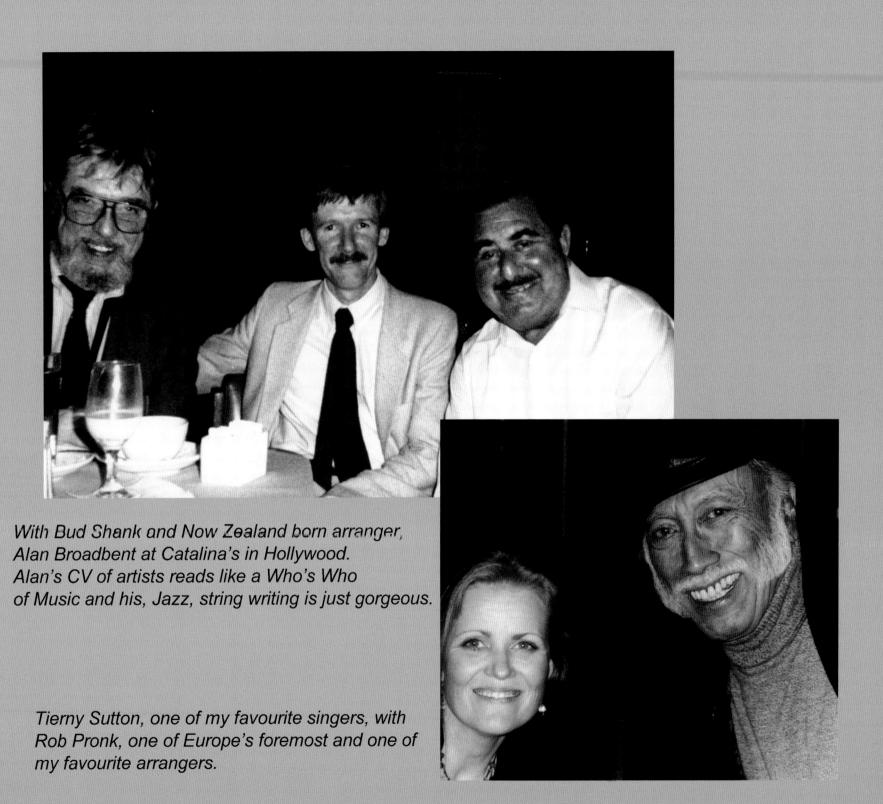

With Bud Shank and New Zealand born arranger,
Alan Broadbent at Catalina's in Hollywood.
Alan's CV of artists reads like a Who's Who
of Music and his, Jazz, string writing is just gorgeous.

Tierny Sutton, one of my favourite singers, with
Rob Pronk, one of Europe's foremost and one of
my favourite arrangers.

Panel discussion
with
Lennie Niehaus,
Bill Perkins
and
Marty Paich.
Los Angeles 1995.

Benny Green, encyclopaedic knowledge
of Jazz, nice saxophone player and above
all a lovely guy.
(Photos Adrian Korsner, Sound Images)

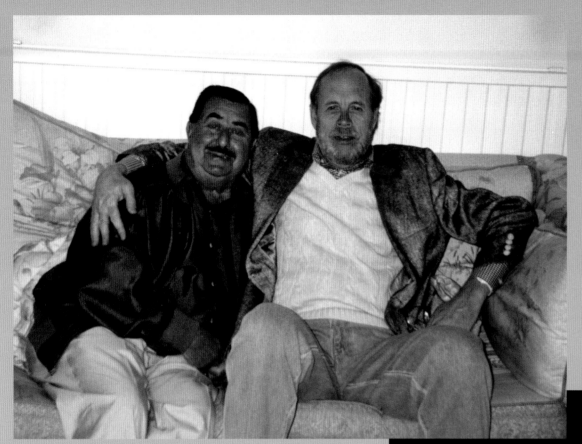

With Jeremy Lubbock, who played piano, briefly, in my band and has become one of the finest composers and arrangers in Hollywood. Barbra Streisand, Michael Jackson, Natalie Cole and Kenny Rogers are just a few who love to work with him.His writing for strings is to die for!

It was lovely to meet up again with Robert Farnon when we both worked on the Royal Festival Hall charity concert for the blind, with Dizzy Gillespie and the Royal Philharmonic Orchestra.
(Photo Adrian Korsner, Sound Images)

With Shorty Rogers and Marty Paich after lunch
at their favourite nosh bar, 'Smokey Joe's' on Riverside.

Photo (Howard Lucraft)

With Pete Rugulo, discussing his composition 'Hammersmith Riff' which Vic's orchestra had just recorded. (early 1950's)

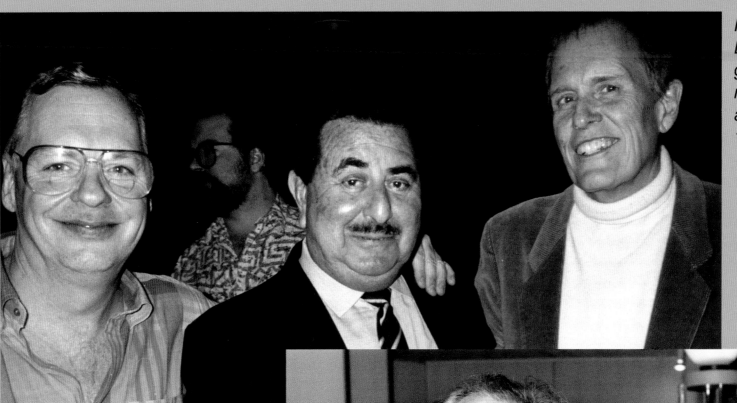

Rob McConnell (l) and Bob Florence, whose great bands re-enthused my interest in big band arrangements in the 1980's.

Michel Legrand, a great Jazz composer and arranger who is better known for his film and pop work. Also a wonderful and melodic jazz pianist.

Photo Oliver Upton

Reunion in Oldham UK
Unknown (drs)
Jiggs Whigham (tbne),
Bill Perkins (tnr).
John Vorster (bss)
Bud Shank (alto)
Shorty Rogers (tpt, arr) (seated)

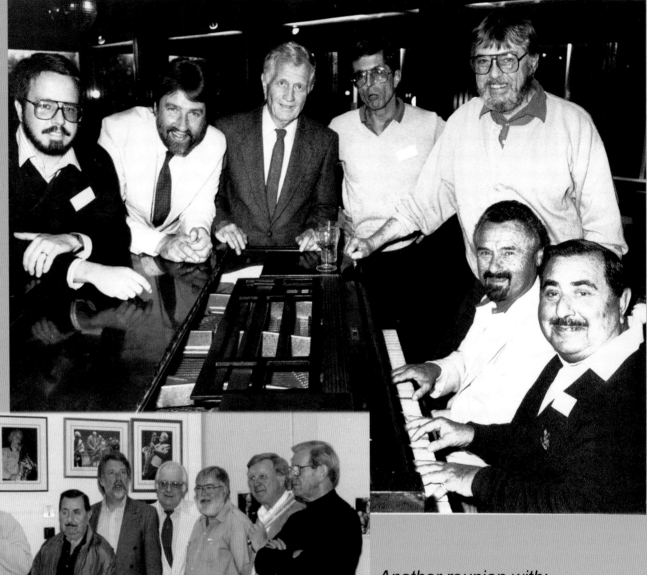

Another reunion with:-
Charlie Mariano (alto)
Bill Perkins (saxes)
Rob Pronk (arr)
Jiggs Whigham (tbne)
Murray Patterson (Promoter)
Buddy Childers (tpt)
(drs)
Bob Holness, Radio and TV presenter
and wild Kenton Fan!

(Photo Adrian Korsner, Sound Images)

With Shorty Rogers
New York in the 80's.

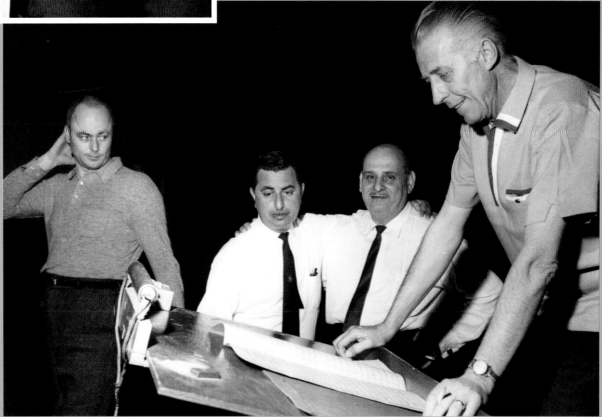

With Gene Roland, Johnny RIchards
and Stan Kenton at recording of the
Christmas Album in Hollywood.

More Friends

The motley group of layabouts and neer-do –wells in this section are some of my closest friends.
They have been in and out of my playing career throughout the years and demand to be in the book.

Bill Holman.

Bob Findlay, Shorty Rogers and
Maynard Ferguson.(tpts)
(Photo Adrian Korsner, Sound Images)

Allan Ganley (drs) and Vic Ash (saxes)

Stan Levey (drs)

Mel Torme the 'Velvet fog' and great driver.

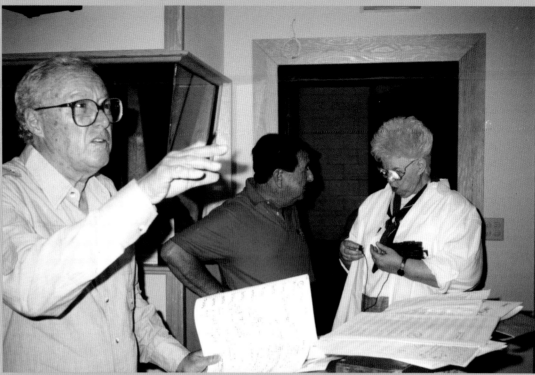

Pete Rugulo and Chris Connor.

Comparing noses with Jack Nimitz (bar).
(Photo Adrian Korsner, Sound Images)

Pete Christlieb (tnr) a truly popular and amazing player.
(Photo Adrian Korsner, Sound Images)

With Billy May in LA.

Tom Talbert (leader), Alan Broadbent (pno, arr).
(Photo Adrian Korsner, Sound Images)

Enjoying a joke with Bob Florence, a favourite arranger
and leader. Newport Beach, California 1991.

With Laurindo Almeida (gtr) in LA.
(Photo Adrian Korsner, Sound Images)

Tony Bennett at Chaplin Studios Hollywood at a memorial concert for Monty Budwig. Tony flew from New York to sing three numbers and then went back. We had not met for a few years since I had managed his European tours in the 60s.

Nelson Riddle on his boat. Preparing to take me out (against my wishes) for a tour of the harbour. He took me further out to sea and I got sick!. I forgave him.

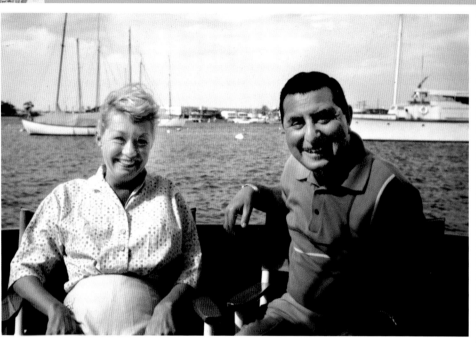

Sitting with June Christy in Carlos Gastel's boat. Carlos worked with Stan Kenton and Nat King Cole too.

Jill and Johnny Mandel, actually in his garden in Malibu. The backdrop is the Pacific Ocean.

Guitarist Mundell Lowe, his wife, Betty, my wife Jill and Jack Wheaton. At the Lowe's house in LA.,before their move to San Diego.

First meeting with bandleader Les Brown at a Big Band reunion in Hollywood at the Sportsman's Lodge Hotel.

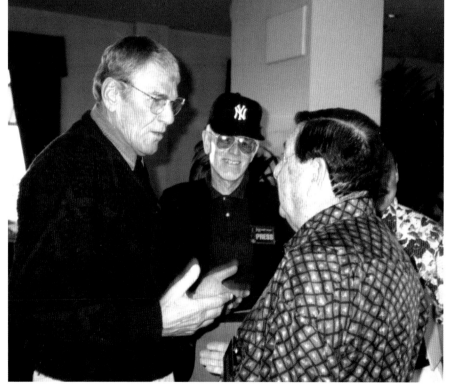

Stan Levey "its been a long time since Holland in the 50's". Meeting up in California in 2000. (Photo Adrian Korsner, Sound Images)

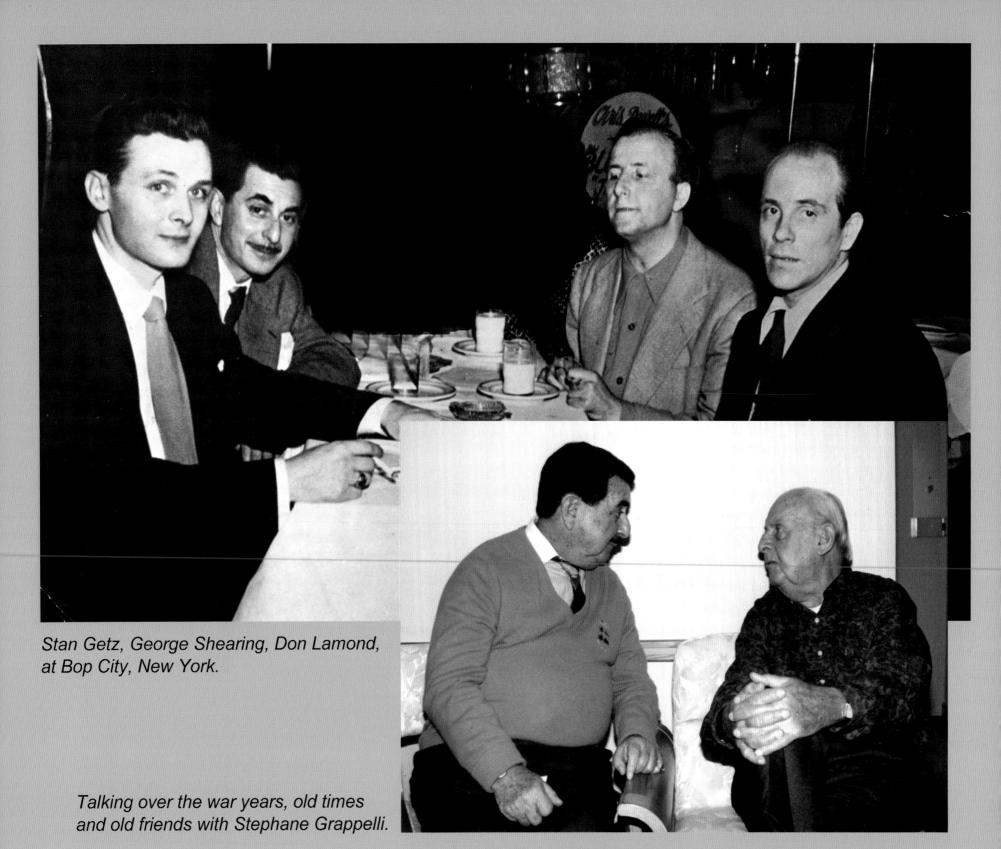

Stan Getz, George Shearing, Don Lamond, at Bop City, New York.

Talking over the war years, old times and old friends with Stephane Grappelli.

96

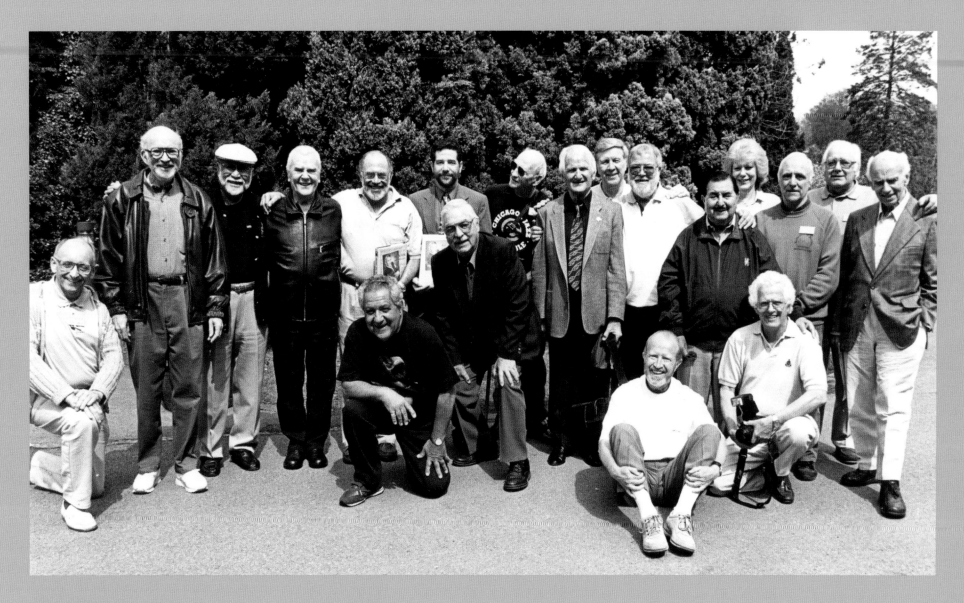

80th Birthday party at Egham Surrey, 1999.
(Kneeling & Sitting) Arnie Chadwick, unknown, Bill Trujillo (tnr), Don Reed, Jim Amlotte.
Standing, Lennie Niehaus (alto, arranger), Gabe Baltazar (alto), Charlie Mariano, (alto) Mike Vax (leader),
Stephen Harris (author of book on Stan Kenton), Leo Curran, Conte Condoli (tpt), Jerry Mackenzie (drs),
Buddy Childers (tpt, leader), Anne Patterson, John Healy, Murray Patterson,(Organisers) Milt Bernhart (tbn).
(Photo Adrian Korsner, Sound Images)

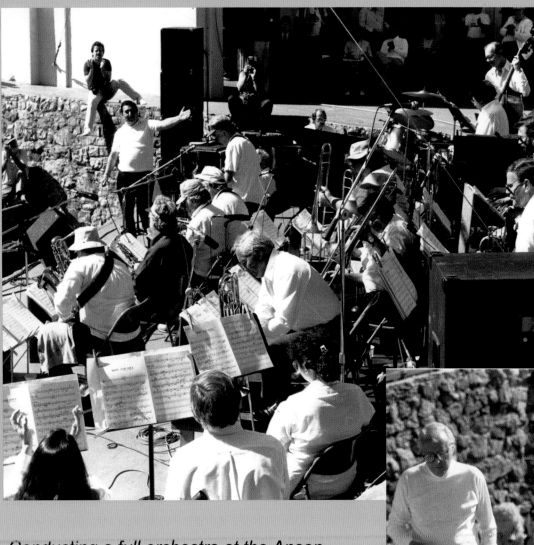

Conducting a full orchestra at the Anson Ford theatre, acknowledging a fine solo from Bill Perkins.

Conducting Intermission Riff as a finale with Pete Rugulo, Shorty Rogers and Marty Paich.

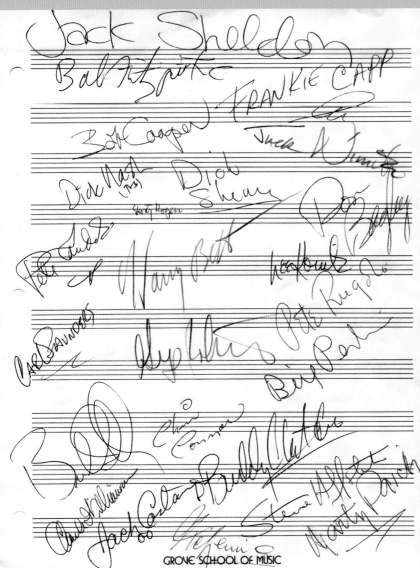

Anson Ford concert rehearsal and an autographed page of many of those taking part.

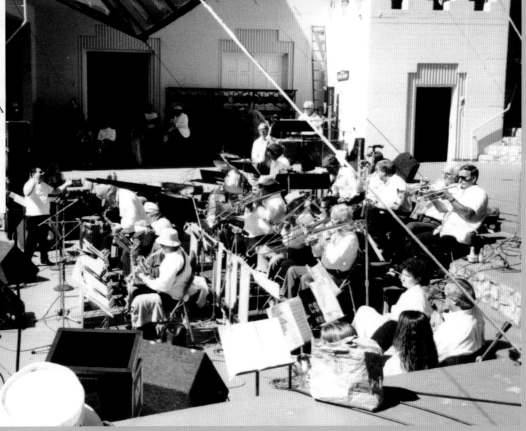

99

Some of Kenton's 'angry young men' ! (some years later) c.2000.
Bill Russo (tbn arr), Milt Bernhart (tbn), Jiggs Whigham (tbn), Roy Reynolds (tnr), Lee Konitz (alto), Buddy Childers (tpt).
(Photo Adrian Korsner, Sound Images)

Our first meeting with the Mulligans in 1954 in Paris.
Gerry and Arlene (rt) Jill and I (l).

Below:Visit with Gerry when he played at the
Royal Festival Hall with the Royal Philharmonic. (Mid 80's).
(Photo Adrian Korsner, Sound Images)

Gerry comes to his first cricket match at Mill Hill Village.
Never really understood what it was all about! Mid 70's.

Jeff Hamilton in Germany. 1995. (Photo Wolfgang Weiss)

Gary Foster (alto) who has worked on several of the latest albums. (Photo Adrian Korsner)

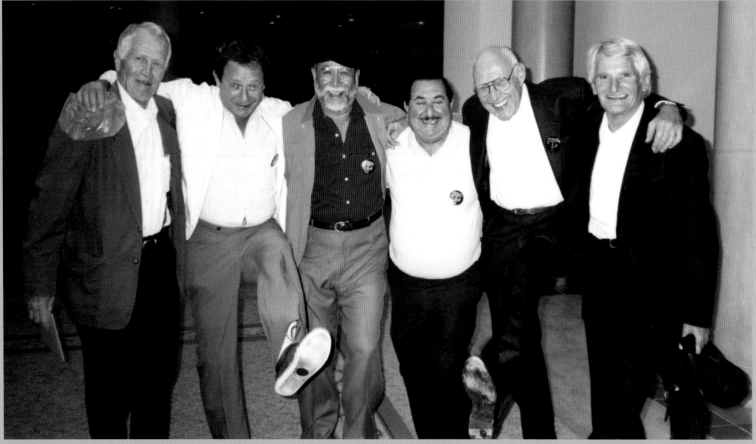

High Kicks with Bill Perkins, Russ Freeman, Gabe Baltazar, Herb Geller and Conte Condoli.
(Photo Adrian Korsner, Sound Images)

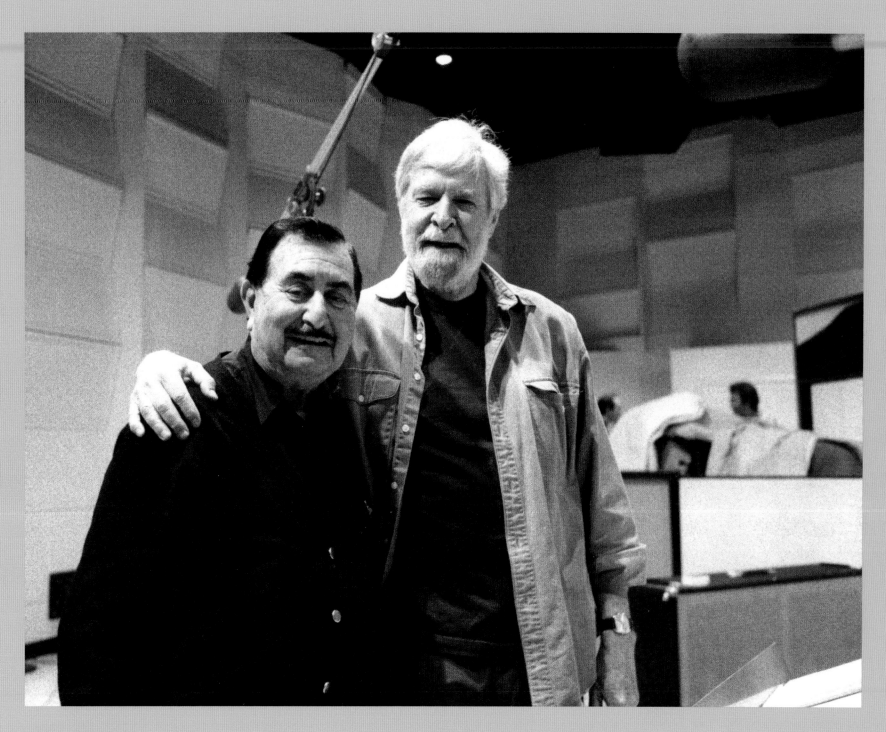

WIth Bill Holman at the recording of his award winning 'Tribute to Monk' album.
Photo Bill Claxton.

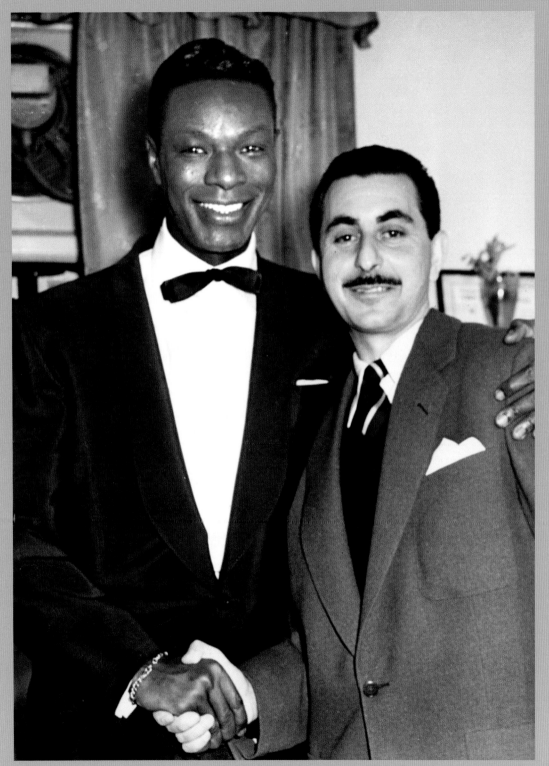

My number one vocal star and jazz pianist! Nat Cole.

With Lance Kenton, chatting about his dad Stan. (Photo Adrian Korsner, Sound Images)

At 'The Grove' with Dick Nash, the number one all round trombone player.

top Left. Jimmy Guiffre (tnr) and Claude Williamson (pno) in LA.
(Photo Adrian Korsner, Sound Images)

With Andy Martin, between sets in LA.

Jiggs Whigham (tbn), Jill Lewis, Manny Albam (arr) In LA. (Photo Adrian Korsner, Sound Images)

Jack Constanza, Nat Cole and Stan Kenton's bongo player.
(Photo Adrian Korsner, Sound Images)

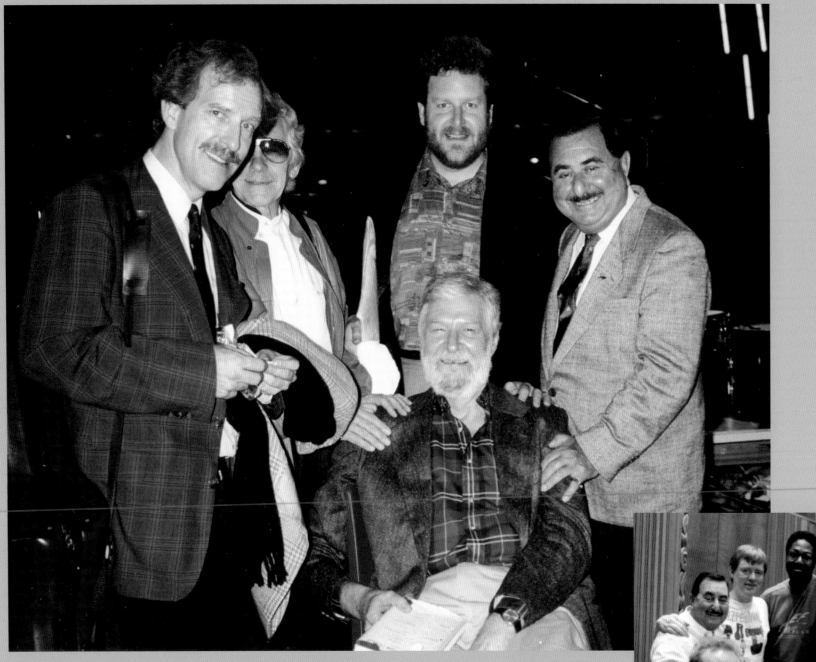

At Hilversum, Holland, for the recording of the Bill Holman Band Radio Show.
Ferdinand Povel (tnr), Jerry Van Rooyen (arr), Jeff Hamilton (drs) and Bill (seated)

With some of the WDR musicians who played in the Bill Holman
Band in Cologne. Frank Chestenier (pno) Mats Winding (bs),
Dennis Mackrel (drums). Photo Wolfgang Weiss.

Johnny Best (tpt) San Diego 1997.

A quick 'pint' with Marty Paich and Manny Albam.

Carl Saunders (tpt) England 1998.

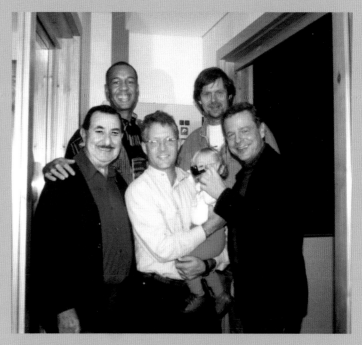

John Clayton, Andy Martin and Angelina,
Fritz Bayens (producer), Bart Van Lier (tbn)
at Andy's session with the Metropole, 1996.

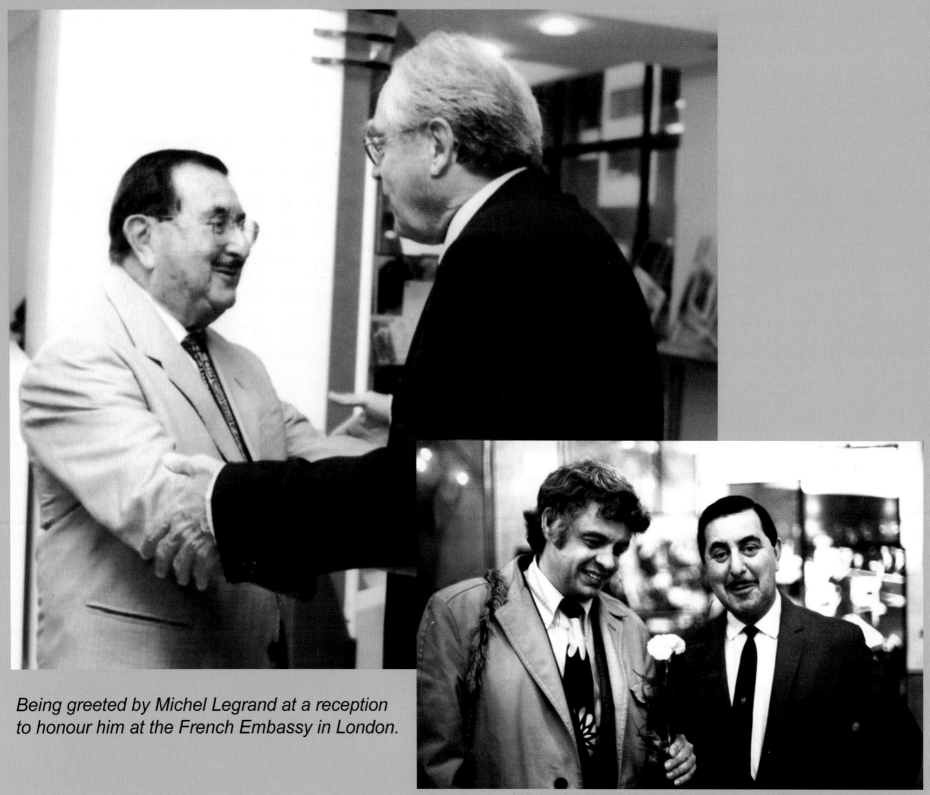

Being greeted by Michel Legrand at a reception to honour him at the French Embassy in London.

With Maynard Ferguson on a working trip to Prague.

108

With two old friends in Germany. Bill Holman (arr) and Bob Brookmeyer (arr, tbn).

Terry Gibbs (vbs).
In London (above)·
(Photo Adrian Korsner, Sound Images)

(above)
Ralph Blaze (gtr)
Red Norvo (vbs)
Shorty Rogers (tpt).
Ralph sent this
picture, knowing
my love of Shorty.

Johnny Mandel and
Michael Lang at a
Mandel session.

Gerry Mulligan

writes about Kenton and Vic Lewis

IT'S always interesting to me to hear someone else's approach to my numbers—such as the Vic Lewis band's LP with arrangements by Johnny Keating.

One criticism of Vic's things, in the writing, would be his choice of the blowing progressions. He used other changes than the ones inherent in the tunes, and I think that made for lack of cohesion in the arrangements themselves in certain spots.

I really don't know his reason for doing that. . . . I know that in one piece they used an "I Got Rhythm" release when it should have been a "Honeysuckle Rose" release, and that's the sort of switch I can't understand, because in the original piece the changes weren't so complicated as to give anybody any real trouble.

itself, and the horns begin feeling like they're leaning a little hard on the tempo. But all in all, I think Vic produced a very interesting album.

On a couple of the arrangements I did for Stan—namely, "Night And Day" and "Begin The Beguine," I felt I did some of my best writing for him, yet he never played them at all.

In fact, I had a very funny experience with one. I was walking by a record shop in Hollywood one day when I saw a Kenton album with "Begin The Beguine" listed on it.

Romantic

My gosh! I thought; he's recorded it! So I went in and listened and found that I didn't remember writing what I heard.

I didn't. It was another arrangement.

The one I'd written was not as a beguine, but rather as a simple four. The one on the record was, in my opinion, quite without character.

I guess I should never have been surprised that Stan didn't play my arrangement of "Night And Day" as it was a very romantic-type thing. It was kind of a Ravel sound, a very lush thing which I did do as a beguine. I hope he gave that one to Vic Lewis—I'd like to hear how the arrangement came out!

Tempos

When Vic used arrangements that I originally wrote for Stan Kenton, I got the same sort of feeling as I got with Stan's band: they had difficulty playing the arrangements at the tempo I felt they *should* be played.

Almost without exception Stan played my arrangements too fast, and I felt that this might have been due to their simplicity.

The biggest problem with my things seems to be the tempo. I noticed that in Vic's arrangements the rhythm section seems to run out from under the band

The picture on right shows Vic Lewis (left) at one of his more recent meetings with his mentor, Stan Kenton.

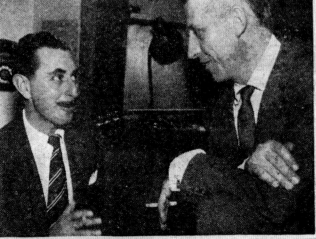

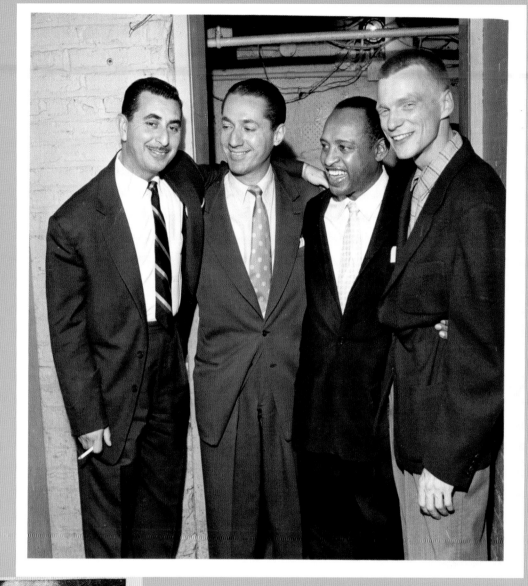

With Leonard Feather, Lionel Hampton and Gerry Mulligan.

Melody Maker 1955.

Conte Condoli (tpt) and Milt Bernhart (tbn) 1998 in England, holding photos of us from fifty years earlier. Bill Perkins (sax) looks on. We couldn't find a photo with him.
(Photo Adrian Korsner, Sound Images)

Lee Konitz, Jiggs Whigham, Rolf Erickson, Caledonian Hotel, Edinburgh during the TDK presentation for Kenton.

Clockwise from top left: Buddy de Franco (cl) UCS. London,
Herb Geller (alt) and Rob Pronk (Arr) London,
Bobby Shew (tpt) UCS.London, Jimmy Deuchar (tpt), Ronnie Scotts London.
(Photos Adrian Korsner, Sound Images)

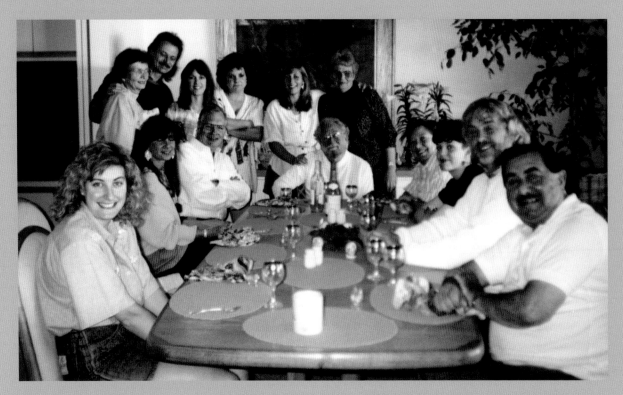

Danielle Lewis with, Rob McConnell, Allyn Ferguson and their families.
Taken by Jill at Allyn Ferguson's Easter party.Malibu 1989.

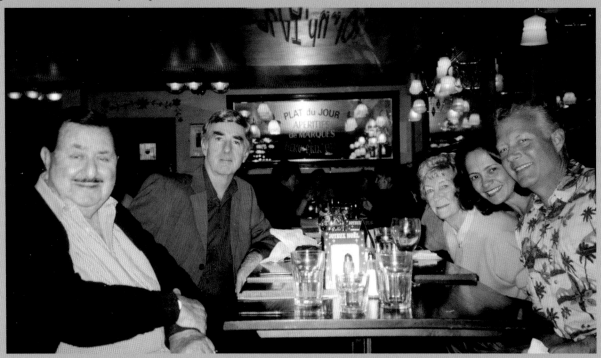

With Robert Feather, Jill Lewis, Angela and Andy Martin, London 2005.

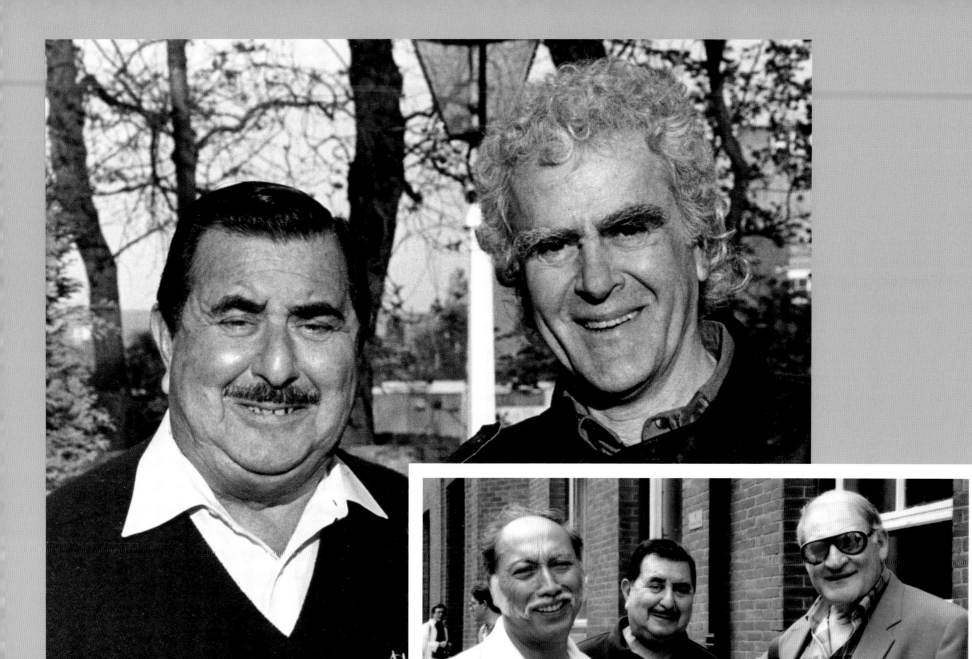

Charlie Mariano a favourite Kentonian
alto player when he came to England to
honour Stan Kenton.

(Photos Adrian Korsner, Sound Images)

Rob Pronk came from Germany to meet up with Vic and
Carl Fontana at the Trombone Festival in Windsor in 1989.

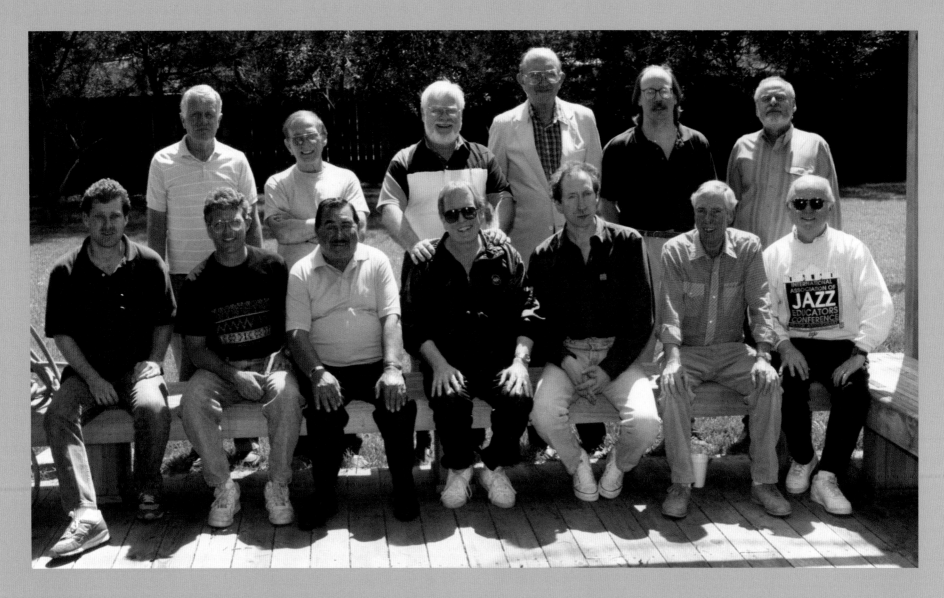

Back (l to r); Bill Perkins (sax), Frank Strazzeri (pno), Clare Fischer (pno) Bob Cooper (tnr),Tom Worthington (bs), Jack Nimitz (bar), Front (l to r) Trevor Feldman (Victor's son), Andy Martin (tbn), (Vic), Bob Florence (pno, leader), Bob Leatherbarrow (drs), Bob Efford (bar), Don Sheldon (sax).

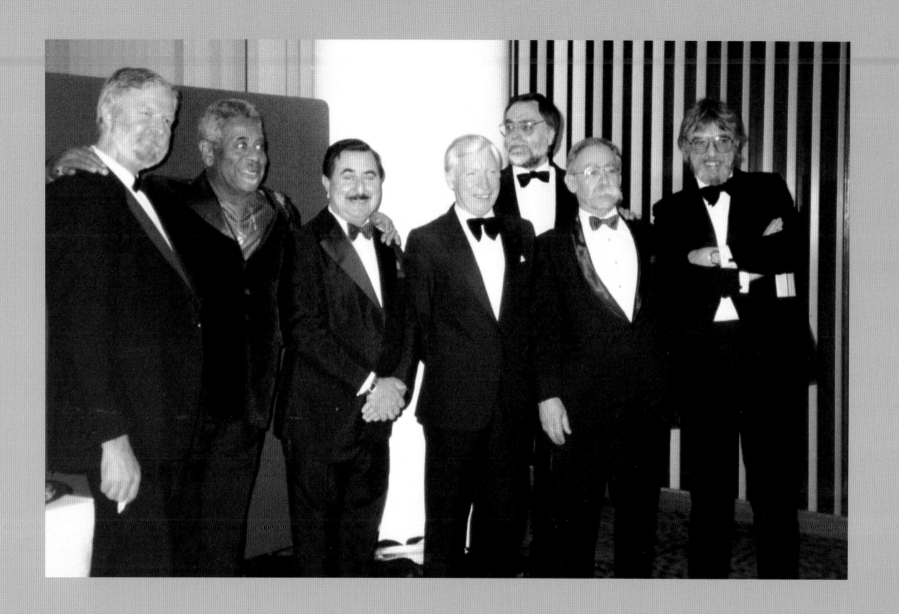

At the Charity concert, in the presence of the Duke and Duchess of Kent, in aid of the Royal School for the Blind, given by Dizzy Gillespie and the Royal Philharmonic Orchestra, at the Royal Festival Hall, November 1985. Bill Holman (arr, cond), Dizzy Gillespie (tpt), Bobby Lamb (tbn), Peter Bould (promoter), Manny Albam (arr, cond), Bud Shank (alt, fl).

(Photo Adrian Korsner, Sound Images)

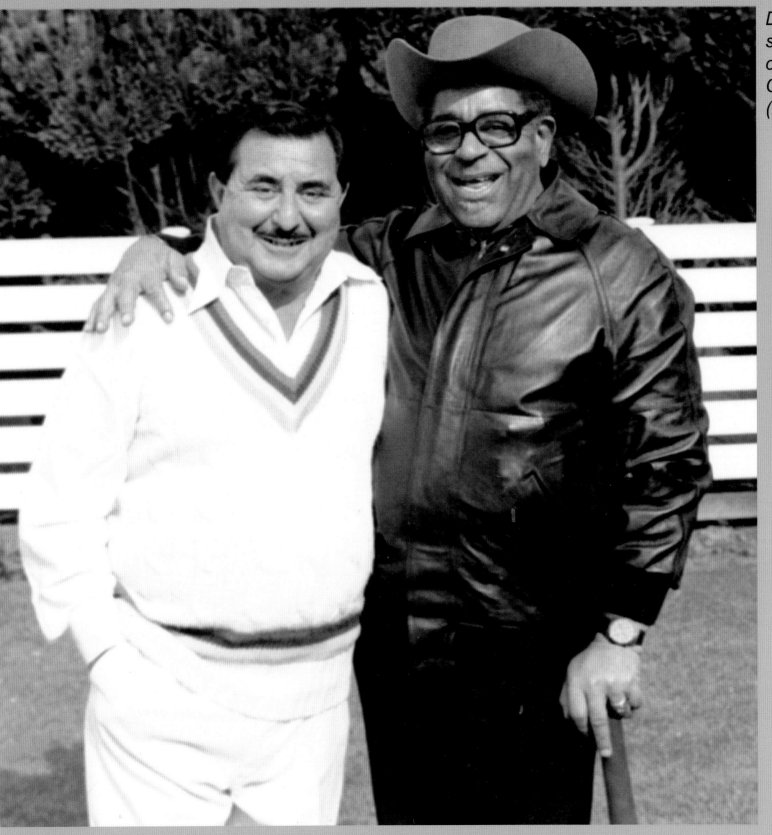

Dizzy GIllespie, staunch supporter of the Vic Lewis Charity Cricket XI. (But no Gary Sobers!)

*Dudley Moore waits for his turn
to take over from Mike Lang (pno), at
a recording session at Grove Studios,
Los Angeles, in 1989, which may
have been his last session.
John Clayton (bs) is at the rear of the
studio.*

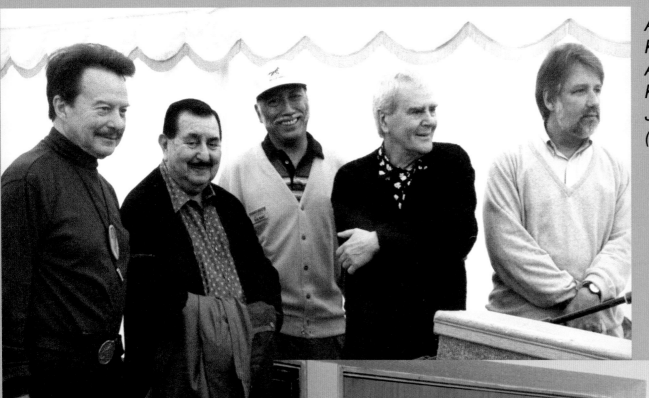

At rehearsals in Egham,
Kentonian, Eddie Bert (tbn)
Arranger Rob Pronk
Kentonians Charlie Mariano (alt) and
Jiggs Whigham (tbn).
(Photo Adrian Korsner, Sound Images)

Murray Patterson, devotee of
Stan Kenton and co-organiser of
Kenton events in the UK and
America.
Andy Martin (tbn, seated)
and Johnny Keating (arr) took
over writing for the Lewis Orchestra
after Ken Thorne's departure.
Keating later wrote for Ted Heath.
Egham 1999.
(Photo Adrian Korsner,
Sound Images)

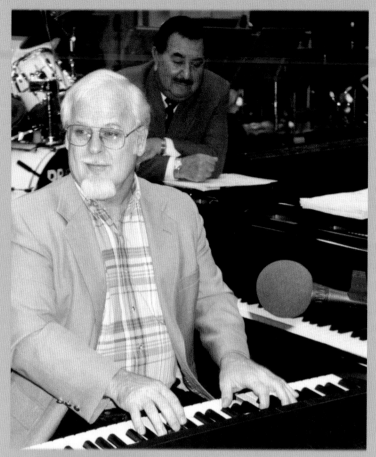

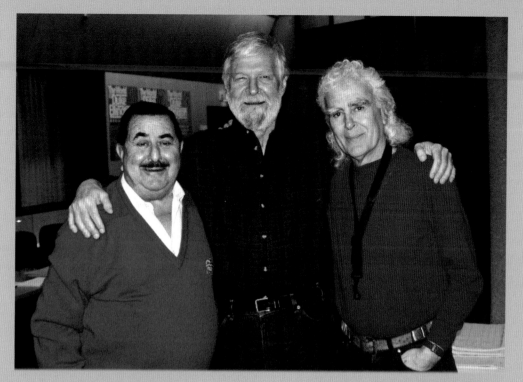

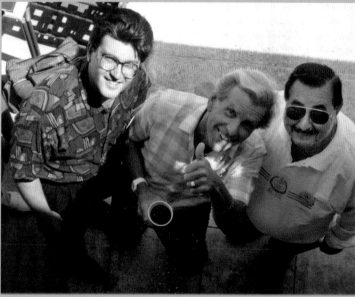

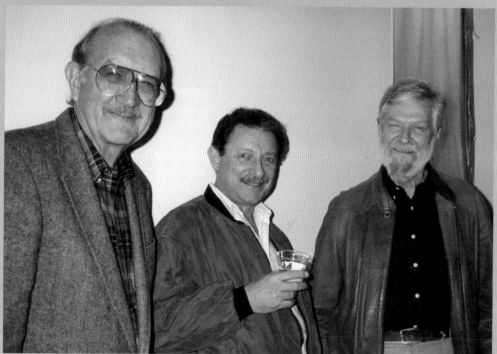

Top, Clare Fischer, Hilversum Radio.
Below, Ken Poston, Jazz promoter and
broadcaster and Bob Holness broadcaster
and Jazz lover. (Photos Adrian Korsner)

Top, Bill Holman (arr) and Charlie Mariano (alt) at a session with
the WDR and large string section in Cologne, Germany.
Below, Bob Cooper (tnr) and Russ Freeman.(pno), Bill Holman,
in LA. (Photo Adrian Korsner, Sound Images)

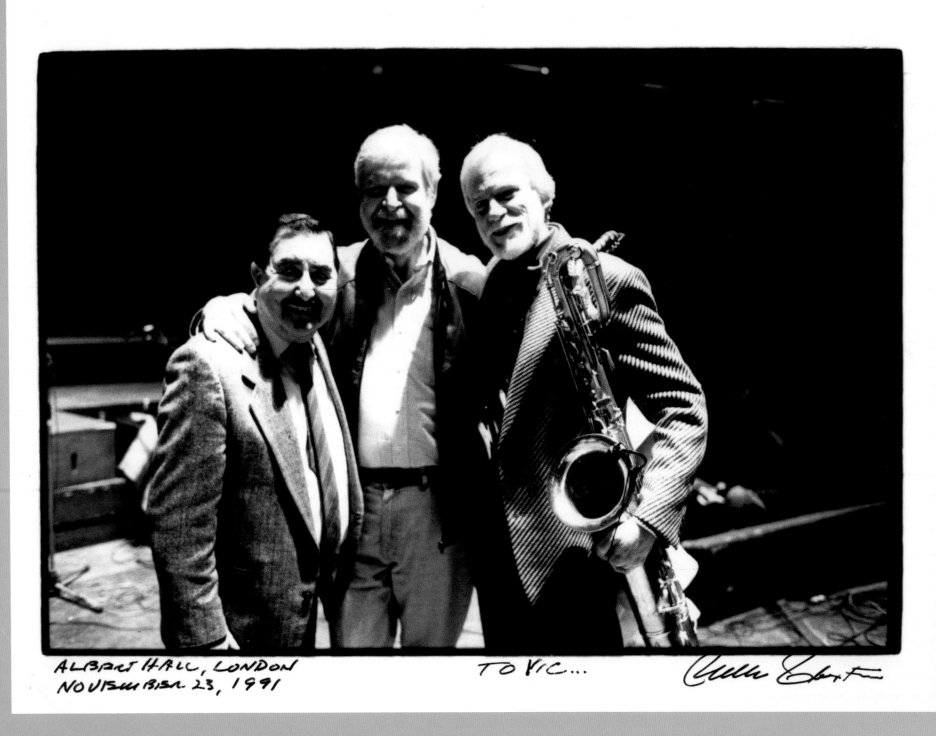

ALBERT HALL, LONDON
NOVEMBER 23, 1991

TO VIC....

Bill Claxton took this picture with Bill Holman and Gerry Mulligan at the 1991 concert at the Albert Hall.

Gary Foster (Alto) in LA. (Photo Adrian Korsner, Sound Images)

Jack Sheldon (tpt) in LA. First recorded together in 1963 and still recording together in 2003.

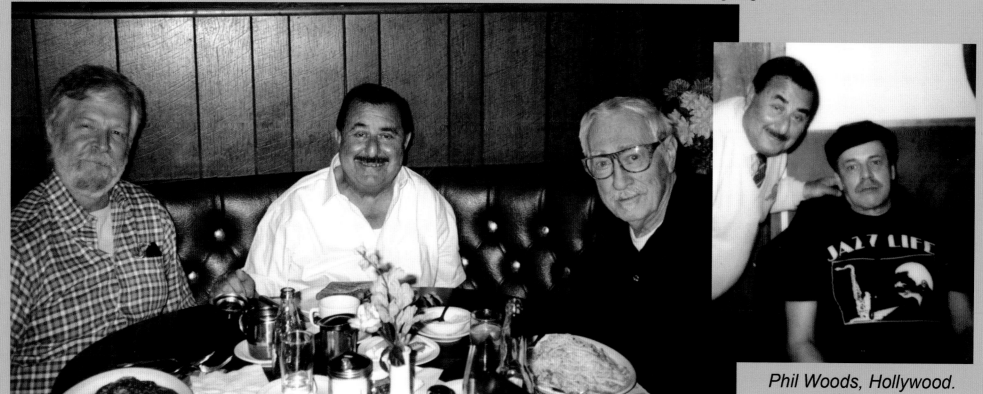

With Bill Holman and Jimmy Rowles, 1996 LA.

Phil Woods, Hollywood.

Concerts

The idea of paying tribute to Stand Kenton in the UK was originally mooted by Arnie Chadwick,
a Kenton record enthusiast, and at his suggestion I brought over a number of Stan's musicians to
Oldham, in Lancashire, where a tribute concert was staged. The series continued for a number of
years under the guidance of Murray Patterson right through until his unfortunate illness in 2000.
In America, to this day, Ken Poston also runs, for the American Institute of Jazz, yearly or half-yearly
concerts, not only of Stan's music (but mainly), but also tribute concerts to other famous names
of the past like Woody Herman, Terry Gibbs, Buddy DeFranco,

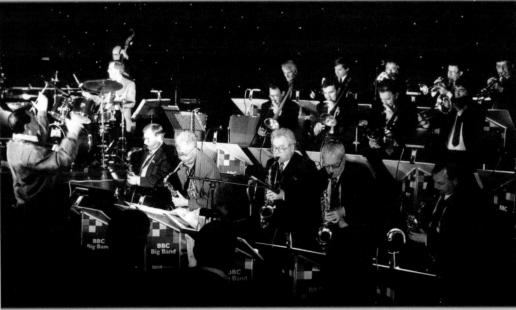

At work Conducting, (Clockwise from top left) Andy Martin, Egham; Charlie Mariano, Oldham; Bill Perkins,
Charlie Mariano, Conte Condoli, Buddy Childers and the BBC orchestra Egham; Lee Konitz, Edinburgh.
(Photos Adrian Korsner, Sound Images)

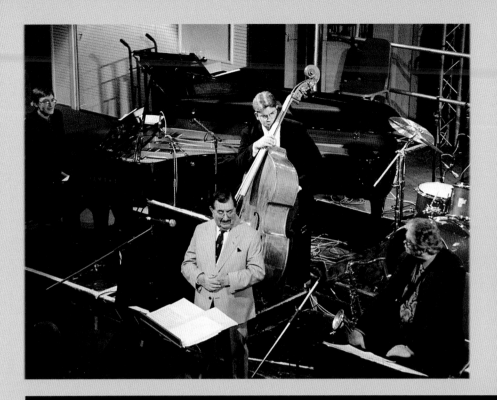

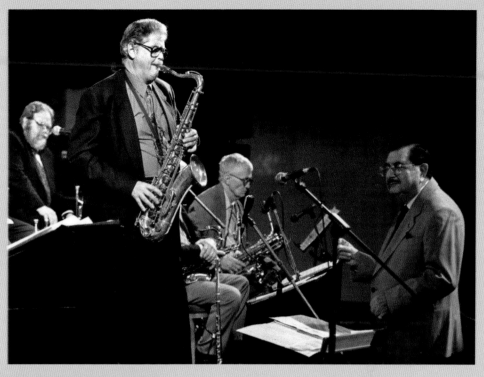

Left, Christian Jacob, Trey Henry (bs)
Pete Christlieb (tnr) Egham.
(Photo Adrian Korsner, Sound Images)

Right, Ron Stout (tpt)
Pete Christlieb (tnr)
Bill Perkins (sax).
(Photo Adrian Korsner, Sound Images)

Conducting Bud Shank with the RPO
at the Royal Festival Hall for a TV
recording. (Photo David Redfern)

October 29, 1955. MELODY MAKER Page 11

ROYAL HONOURS FOR VIC LEWIS & SHOW BAND

THE Vic Lewis Orchestra and Cyril Stapleton with the BBC Show Band, the Show Band Singers and the Star-gazers have received the profession's top honour by being invited to appear at the Royal Variety Performance which will be presented by Jack Hylton, at London's Victoria Palace, on November 7.

Royal laurels also fall on Ruby Murray, current singing star at the London Palladium, who was practically unknown just over a year ago, and America's Johnnie Ray and Lena Horne.

Johnnie is currently playing at the London Hippodrome, and Lena Horne is in cabaret at the Savoy Hotel.

The Lewis Orchestra will be making its first Royal Performance appearance. Vic told the MM: "I'm thrilled. It's the greatest thing that has happened in my career to date."

Hat-trick

Cyril Stapleton and the Show Band have played before the Queen twice previously—at Windsor Castle last year, and on a Royal Command Broadcast in 1953—but this will be their first Royal Variety Performance ap-pearance.

Says Cyril: "I'm extremely pleased. It makes our hat-trick."

Joint musical directors of the show will be Billy Ternent, who recently signed as a musical ad-viser to the Hylton organisation, and Ronnie Munro, MD at the Victoria Palace.

Other stars taking part include Alfred Drake, Doretta Morrow and the "Kismet" Company, the Crazy Gang, Diana Dors, Jimmy Edwards, Dave King, Tommy Trinder, Benny Hill, Bobby Howes, Pat Kirkwood and the "Salad Days" Company,

The Royal Variety Orchestra.

Being presented to Princess Margaret.

HRH Princess Michael of Kent meets Bill Holman and Manny Albam at the Charity Dizzy Gillespie Concert at the Royal Festival Hall, 1985.

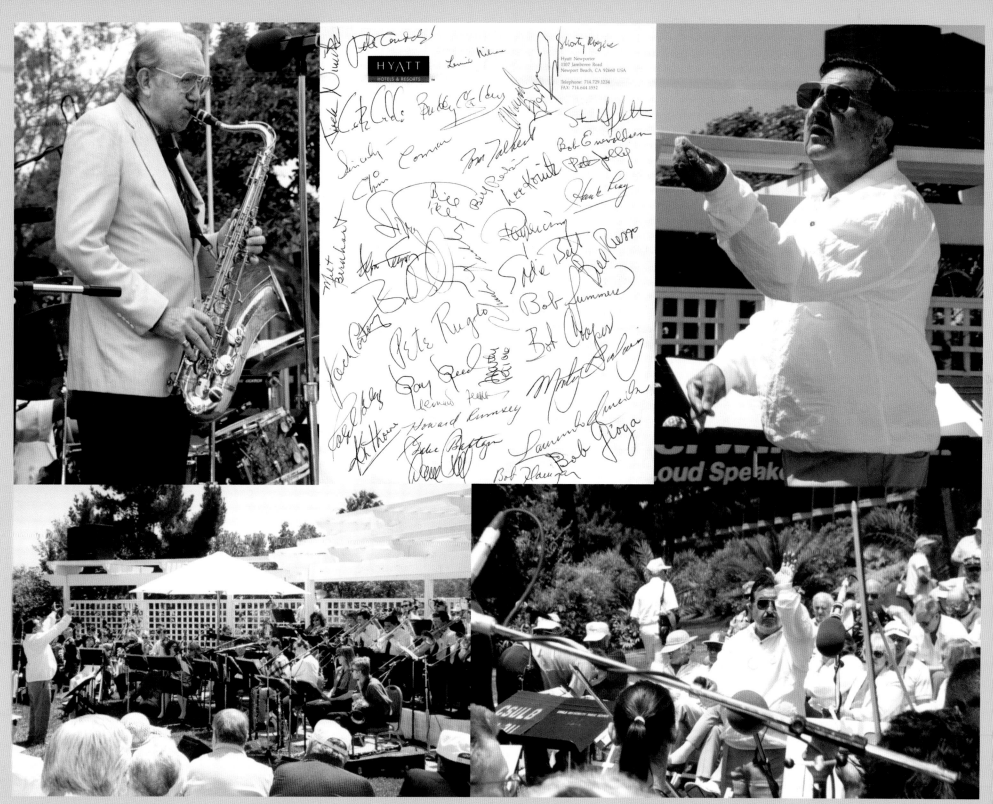

Bob Cooper plays, Vic conducts a Kenton 'Innovations' orchestra at Newport Beach, California. Inset signatures of just some of the ex Kentonians who came to celebrate Stan. (Photos Adrian Korsner, Sound Images)

127

The Project Years

Before 'The Project' idea was formulated I had made seven CDs featuring Andy Martin with myself as conductor. These recordings usually consisted of groups of five to eight musicians with small head or head orchestrations. However, it had been nagging me for some time to discuss with Andy the possibility of recording with a large jazz orchestra and using his talent for over-dubbing to create on the recordings a five trombone multiplication of his unique sound. We also called on the services of some of the greatest arrangers (as illustrated in the ensuing pages), with Rob Pronk developing a string section for the recordings.

It was during this period, in October 2004, that I was honoured to receive a Gold Award from the British Academy of Composers and Songwriters.

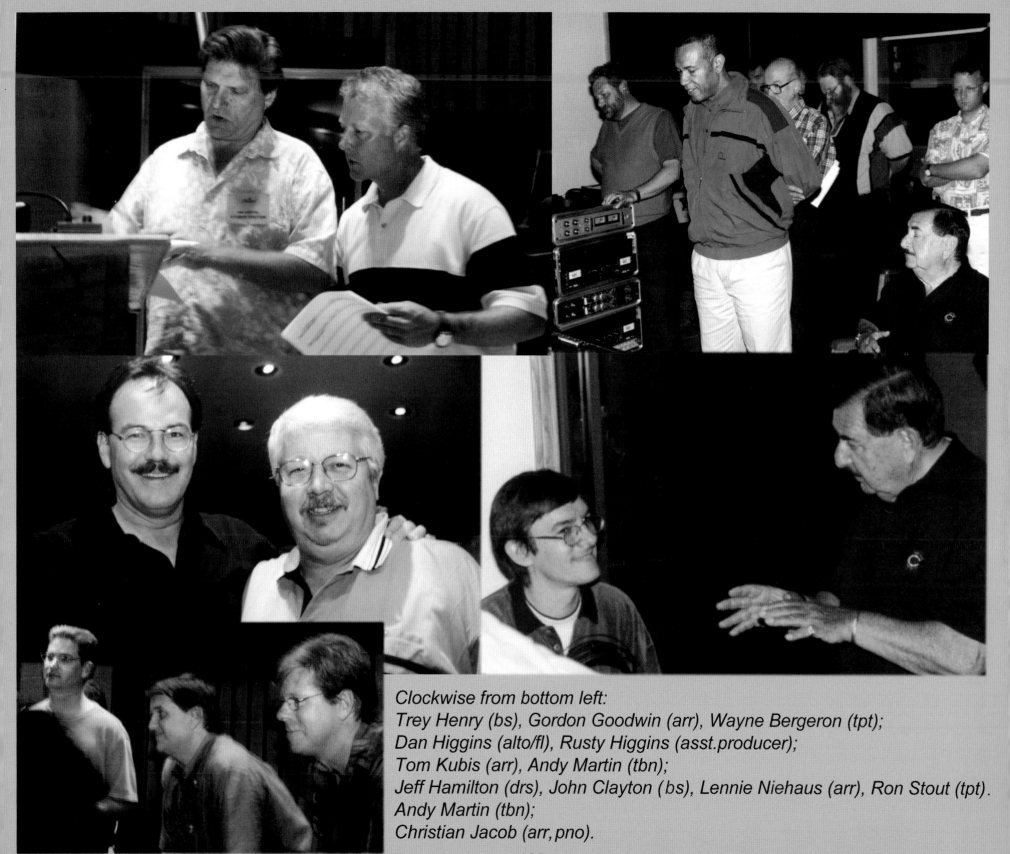

Clockwise from bottom left:
Trey Henry (bs), Gordon Goodwin (arr), Wayne Bergeron (tpt);
Dan Higgins (alto/fl), Rusty Higgins (asst.producer);
Tom Kubis (arr), Andy Martin (tbn);
Jeff Hamilton (drs), John Clayton (bs), Lennie Niehaus (arr), Ron Stout (tpt).
Andy Martin (tbn);
Christian Jacob (arr, pno).

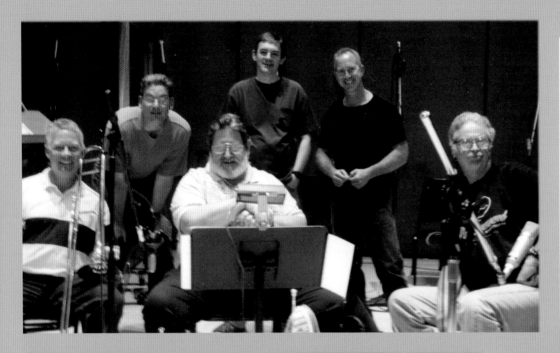

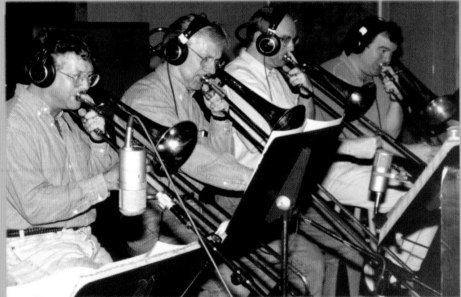

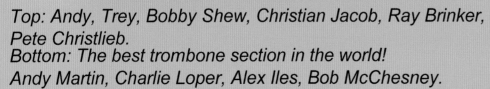

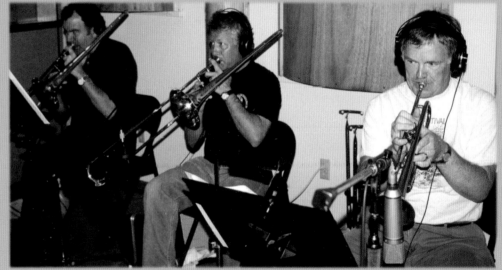

Top: Andy, Trey, Bobby Shew, Christian Jacob, Ray Brinker, Pete Christlieb.
Bottom: The best trombone section in the world!
Andy Martin, Charlie Loper, Alex Iles, Bob McChesney.

Top: Andy, Trey, Christian, Ray.

Bottom: Bob McChesney, Andy, Bob Summers.

Photos from some of the 'West Coast' and 'Project' sessions.

BRITISH ACADEMY *of* COMPOSERS & SONGWRITERS

Presents

THE 30TH ANNUAL GOLD BADGE AWARDS

...red by

mcps

Vic Lewis

THERE WAS A time in the Sixties when Vic and myself were inseparable, a sort of Jewish Ant and Dec.

Vic was running Brian Epstein's Nems organisation and I was his right-hand man. Vic was the all-conquering impresario, looking after the UK careers of Nat King Cole, Andy Williams, Tony Bennett, The Everly Brothers and dozens more. This was a golden period in both our lives. We travelled the world together, first class, of course. Vic wouldn't have it any other way. We collaborated on songs and people recorded them! This was in the days when singers didn't insist on writing everything themselves. The Vic Lewis Orchestra was regarded as one of the best ever to come out of this country and was often compared to the great Stan Kenton's. But, I really got to know Vic when he put down his baton and became the great theatrical agent. Although I will never forget those marvellous meals with the likes of Nelson Riddle, Mel Tormé, Johnny Mathis, Shirley Bassey, etc., it's his personal idiosyncrasies that stick out. Vic is one of the world's great hypochondriacs! However, his ailments were most peculiar. He would arrive at the office and say things like "I'm not myself today, my hair hurts" or "My tongue feels cold". He is also a collector or hoarder of after-shave lotions. In those days he would come up close and test me to see if I could name his chosen fragrance. His bathroom was more like Harrods perfumerie hall. Another of his great passions was stamp collecting. Wherever we went in the world, his first job would be to buy a sheet of local stamps. I'll never forget the time we landed in Saigon at the height of the Vietnam War. As soon as we got off the plane, we heard gunfire and watched the terrified look on the soldiers' faces. This didn't stop Vic rushing up to the tall high-ranking official on duty and saying, "Excuse me, but I save stamps". The man just looked down on Vic and said, "No shit" and walked away.

The other love of his life, almost as much as music, is cricket. He had his own team for years and would go to the ends of the earth to watch a game. I went with him to Karachi once to watch his friend Hanif Mohammed play and was bored stiff. On the other hand, I took him to see *Fiddler On The Roof* in New York and he fell asleep. To each his own.

It's impossible to exaggerate Vic's contribution to the music industry. He has guided the careers of so many of today's megastars. And even though he's been out of the limelight for a while, his presence is still strongly felt. Only recently I was talking with Tony Bennett and when Vic's name came up, Tony beamed and said "Vic, he's the man".

I owe so much to Vic. His humour, his talent, his unique take on life, I love them all. I'm grateful to the Academy for asking me to write these few words about the great man and I wish him, his wife Jill, and his daughter Danni a well deserved fabulous day. ❖

DON BLACK OBE

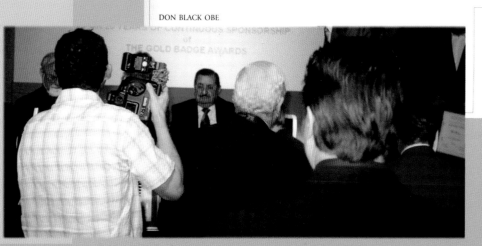

THE 30TH ANNUAL GOLD BADGE AWARDS

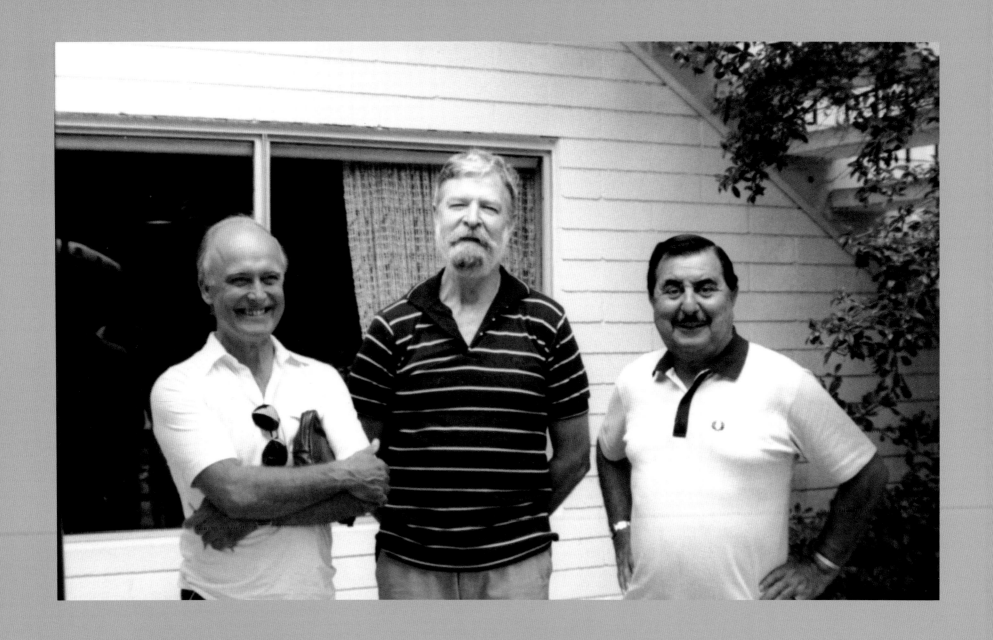

The two men who shaped my life, Ken Thorne and Willis (Bill) Holman.

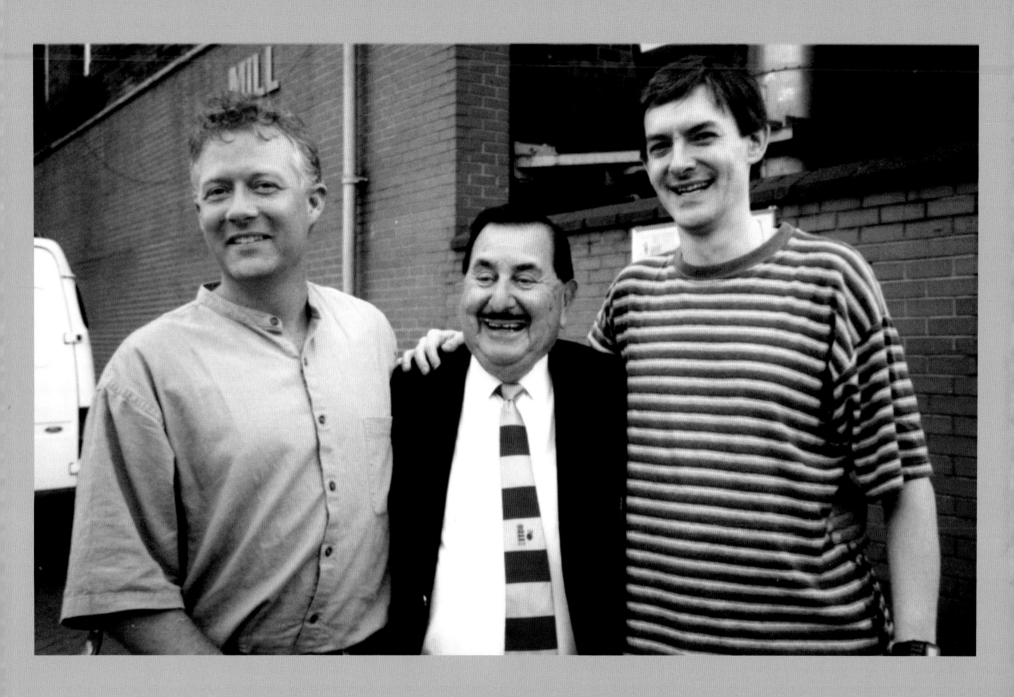

Continuing my Jazz Life with my buddies Andy Martin and Christian Jacob, "the best in the business!".
(Photo Adrian Korsner, Sound Images)

INDEX

Albam, Manny 70, 80, 105, 107, 117, 126
Albert Hall 122
Aldrich, Ronnie 48
Alhambra Theatre 15, 34
Allen, Bernard 32, 43
Allen, Dick 20
Almeida, Laurindo 57, 92
American Federation of Musicians 15
Amlotte, Jim 97
Anson Ford Theatre 79, 98-9
Armstrong, Louis (Satchmo) 27-8, 48, 61
Arnold, Reg 7
Ash, Vic 33, 50, 52, 56, 90
Avery, Ray 31

Bagley, Don 57
Bain, Jock 25
Baker, Kenny 48
Baker, Ronnie 32, 50
Baldwin's Recording Studios
Baltazar, Gabe 97, 102
Barbican Concert Hall 9
Barrow, Tony 52
Basie, Count 31, 59
Bates Club 9
Bayens, Fritz 107
BBC Radio Big Band
Beach, Frankie 11
Bechet, Sidney 13, 59
Bennett, Tony 82, 93
Bergeron, Wayne 129
Bergman, Alan 69-60, 75
Berman, Paul 23
Bernard, Clem 30
Bernhart, Milt 97, 100, 112
Bert, Eddie 120
Best, Johnny 11, 75, 107
Billings, Josh 4
Birdland Club 52, 56
Black, Don 131
Blair, Eddie 51
Blaze, Ralph 110
Blennin, Peter 21
Blue Lagoon 53
Bop City, New York 96
Boswell, Connie 65
Botterill, Jack 21, 25
Bould, Peter 117
Bovil, Vince 23
Bowman, Dave 4

Bradfield, Colin 46, 50
Branscombe, Alan 51
Brinker, Ray 130
British Academy of Composers and Songwriters 128, 131
Broadbent, Alan 70, 83, 92
Bromley, Tommy 9
Brookmeyer, Bob 70, 73, 109
Brown, Johnnie 32
Brown, Les 95
Brubeck, Dave 68
Buddy Featherstonehaugh Quintet
Budwig, Monty 63, 93
Burton, Ron 1
Butler, Jerry 50
Byas, Don 13

Caledonian Hotel, Edinburgh 112
Caluccio, Rocky 11
Calvert, Leon 52, 56
Cameron, John 70
Caceres, Ernie 4, 15
Carnegie Hall 15, 17
Carroll, Jose 4
Carson, Jeannie 8
Carson, Jeri 33
Castle, Lee 2
Catalina's 83
Chamberlain, Ronnie 6-7, 11, 20-1, 23, 30, 32, 43, 46
Chadwick, Arnie 97
Chaplin, Clive 20
Chaplin Studios 93
Chestenier, Frank 106
Childers, Buddy 36, 39, 88, 97, 100, 124
Chisholm, George 10, 51-2
Christlieb, Pete 91, 125, 130
Christy, June 18, 40, 53, 94
Christie, Keith 15, 52, 56
Claxton, Bill 122
Clayton, John 70, 74, 107, 119, 129
Clinton, Dorothy 7
Cole, Natalie 85
Cole, Nat King 60, 76, 94, 104-5
Coleman, Peter 6, 20-1, 23, 30
Collins, John 60
Concertegbouw Concert Hall 21,38
Condoli, Conte 66, 74, 97, 102, 112, 124
Condon, Eddie 1, 4
Condon, Les 51
Condon, Pat 4
Connor, Chris 91

Constanza, Jack 105
Cooper, Bob 17, 62, 116, 121, 127
Courtley, Bert 20-1, 24-5, 30
Costa, Sam 55
Crossman, Fred 29
Curran, Leo 97

Dameron, Tadd 72
Dankworth, Johnny 15, 20, 40
Date With a Dream 8
Davis, Miles 13, 61
Davison, Harold 15,59
Dempsey, Ray 52, 56
Dennis, Denny 30
Deucher, Jimmy 52, 56, 113
Donahue, Sam 11
Dorsey, Tommy 2, 63
Down Beat 17

East, Roy 50-2, 56
Edinburgh 42, 124
Edwards, Len 32
Efford, Bob 23, 116
Egham 97, 120, 124-5
Elefson, Art 52, 56
Ellington, Duke 55
Entourage Studios 90
Erickson, Rolf 112
Evans, Gil 70

Famous Door Nightclub
Farnon, Robert 70, 85
Feather, Leonard 52, 57, 111
Feather, Robert 114
Featherstonehaugh, Buddy 6, 48
Feinstein, Michael 75
Feldman, Trevor 116
Feldman, Victor 57, 116
Ferguson, Allyn 70, 75, 78, 80, 114
Ferguson, Maynard 19, 90, 108
Finch, Harry 23
Findlay, Bob 90
Finnegan, Bill 70
Fischer, Clare 77, 116, 121
Fitzgerald, Ella 53, 65
Fitzpatrick, Bob 34
Florence, Bob, 87, 92, 116
Fontana, Carl 15, 34, 37, 69, 115
Foster, Gary 102, 123
Four Freshmen 54, 58

Fox, Fred 40
Franco, Buddy de 113, 124
Freeman, Russ 63, 102, 121

Ganley, Allan 15, 52, 56, 90
Garnett, Roy 33
Gastel, Carlos 94
Geller, Herb 102, 113
Geraldo 48
Getz, Stan 96
Gibbs, Terry 110
Gilboy, Martin 20, 30
Gillespie, Dizzy 59, 85, 117, 118
Gold, Laurie 48
Goodman, Benny 26
Goodwin, Gordon 70, 129
Gordon, Joe 63
Gould, Alec 32, 50, 70, 73
Gowans, Brad 4
Grappelli, Stephane 1, 9, 96
Gray, Brian 32
Green, Benny 84
Green, Freddy 3
Green, Johnny 20
Greenslade, Arthur 21, 23, 25
Grove Studios 74, 104, 119
Gudice, Joe 10
Guiffre, Jimmy 105

Hackett, Bobby 4, 15, 82
Hall, Harry 50
Hall, Tony 53
Hamilton, Jeff 102, 106, 129
Hammersmith Palais 16
Hampton, Lionel 29, 55, 72, 111
Handy, George 70
Hanes, Alan 1
Harris, Charlie 60
Harris, Stephen 97
Hawkins, Derek 6
Hayes, Tubby 42-3, 52, 68
Healy, John 97
Heath, Ted 55, 120
Hefti, Neil 70, 78
Hendrickson, Al 57
Henry, Trey 125, 129-30
Herfurt, Skeets 2
Hickory House 5, 15
Higgins, Dan 129
Higgins, Rusty 129
Hi-Los, The 63

Hogg, Derek 50
Holman, Bill 36, 40, 70, 80, 90, 103, 106, 109, 117,
 121-3, 126, 132
Holness, Bob 88, 121
Howard, Bert 11
Howe, Peter 23
Hucko, Peanuts 15
Humble, Derek 21, 30
Hurren, Rusty 32
Hutchinson, Leslie 'Jiver' 25, 48

Ingermales, Bev 50
Iles, Alex 130

Jackson, Michael 85
Jacob, Christian 70, 125, 129-30, 133
Jacoby, Don 11
Jenner, Ralph 30
Johnson, Buddy 29
Jolly, Pete 62
Jones, Billy 10
Jones, Dill 53

Kamuka, Richie 63
Katz, Dick 6, 10, 48
Katz, Sidney 25
Kaye, Edna 9
Keating, Johnny 21, 23, 25,30,70, 82, 120
Kent, Duke of 117
Kent, Duchess of 117
Kenton (Richards), Ann 35
Kenton, Lance 104
Kenton, Leslie 11
Kenton, Stan 14-7, 29, 34-6, 40-1, 49, 67, 72, 79,
 89, 94, 97, 100, 105, 112, 115, 120, 127
Klein, Harry 47
Konitz, Lee 36, 100, 112, 124
Koven, Jake 10
Krahmer, Carlo 11
Krahmer, Greta 11
Kubis, Tom 70, 129
Kyle, Billy 27

Laine, Cleo 55
Lamb, Bobby 117
Lamond, Don 96
Lamont, Duncan 50
Lang, Don 23
Lang, Michael 110, 119
Lannigan, Trevor 32
Lapolla, Ralph 11

Lawson, Yank 2
Leatherbarrow, Bob 116
Leddy, Ed 37
Legrand Michel 87, 108
Leopold, Reginald 25
Lesburg, Jack 28
Levy, Hank 70, 72
Levey, Stan 39, 90, 95
Lewis, Danielle, 77, 114
Lewis, Jill 59, 94-5, 101, 105, 114
Lewis, Terry 21, 24-5
Lier, Bart Van 107
Lindbergh, Christian 69
Loban, Dave 32
Logan, Irma 12, 47, 50
London Palladium 33
Longeth, Nick 4
Loper, Charlie 130
Lowe, Mundell 95
Lowe, Betty 95
Lubbock, Jeremy 70, 85
Lucraft, Howard 57
Luff, Howard 13
Lyttelton, Humphrey 48

Mackenzie, Jerry 97
Mackrel, Dennis 106
McChesney Bob 130
McConnell, Rob 68, 74, 87, 114
McRae, Carmen 53, 65
McDonald, Alan 23
McGaskill, Norman 30
McIntyre, Joe 50
McLurdy, Roy 62
McPherson, Dickie 50, 56
McQuarter, Tommy 11
Mancini, Henry 70, 81
Mandel, Johnny 31, 69-70, 75, 94, 110
Mandel, Martha 69
Manne, Shelly 63
Manning, Bill 53
Margaret, Princess 126
Mariano, Charlie 88, 97, 115, 120-1, 124
Marks, Franklin 70
Martin, Andy 73, 80, 105, 107, 114, 116, 120,
 124, 128-30, 133
Martin, Angela 114
Martin, Angelina 107
May, Billy 70,75, 92
Melody Maker, The 14, 111

Mercer, Fred 25
Merrill, Helen 53
Metcalfe, Bill 50
Metropole Orchestra 77, 107
Michael, Princess of Kent 126
Mickleborough, Bobby
Miller, Glen 7
Mince, Johnny 2, 10
Mitchell, Red 32
Montagu of Beaulieu, Lord
Moore, Dudley 50, 119
Moore, Gerry 11
Moore, Shirley 52, 56
Morgan, Howard 32
Morrow, Buddy (see Zudcoff, Moe)
Morte, George 39
Moss, Danny 6, 30
Mulligan, Arlene 101
Mulligan, Gerry 70, 72, 101, 111, 122
Musicians Union 17
Muslin, Joe 1

Nash, Dick 104
New York 1-5
Nick's Club 5
Niehaus, Lennie 34, 37, 70, 76, 80, 84, 97, 129
Nimitz, Jack 66, 91, 116
Noakes, Alfie 25
Norvo, Red 110
Noto, Sam 37
Nuthouse Nightclub 11

Ogerman, Claus 70
Oldham 88, 124
Orr, Bobby 50

Page, Hot Lips 13
Paich, Marty 70, 79, 84, 86, 98, 107
Panassie, Hughes 4
Paris Jazz Festival 13
Parker, Charlie 13
Parkinson, Michael 131
Parnell, Jack 6, 10, 48
Patterson, Murray 88, 97, 120
Patterson, Anne 97
Pepper, Art 17
Perkins, Bill 34, 37, 66, 80, 84, 88, 98, 102, 112, 116, 124-5
Peterson, Oscar 61
Poole, Jim 50

Poston, Ken 121
Povel, Ferdinand 106
Previn, Andre, 70-1
Project, The 128-30
Pronk, Rob 70, 83, 88, 113, 115, 120, 128

Quest, Johnny 7
Quinks, The 12

Raiser, Una 75
Ramblers, The 21
Raymond, Dean 33
Reed, Don 97
Reinhardt, Django 1, 59
Rendell, Don 34-5
Reynolds, Stan 24
Reynolds, Roy 100
Richards, Ann see Kenton, Ann 35
Richards, Johnny 70, 89
Riddick, Billy 6
Riddle, Bettina 81
Riddle, Cecily 81
Riddle, Nelson 52, 70, 77, 81, 94
Riddle, Rosemary 81
Rogers, Kenny 85
Rogers, Shorty 57, 70, 79, 86, 88-90, 97-8, 110
Rodgerson, Brian 32, 43, 50
Roland, Gene 70, 89
Ronnie Scott's 113
Rooyen, Jerry van 106
Rose, David 70, 78, 81
Ross, Annie 55
Ross, Edmundo 48
Ross, Ronnie 51-2, 56
Rossolino, Frank 38-9
Rowles, Jimmy 123
Royal Festival Hall 25, 32, 71, 85, 101, 117, 125-6
Royal Philharmonic Orchestra 40, 52, 85, 101, 117, 125
Royal School for the Blind 117
Royalty Theatre, Johannesburg 44
Royal Variety Show 45, 126
Rugulo, Pete 16, 18, 70, 74, 78-9, 86, 91, 97-8
Russell, Pee Wee 4
Russo, Bill 36, 39, 70, 100
Ryan, Marion 55

Saunders, Carl 107
Sauter, Eddie 70
Schertzer, Hymie 2
Schildkraut, Dave 36, 40

Scott, Ronnie 51-2, 68
Shakespeare, Johnny 6
Shank, Bud 57, 66, 83, 88, 117, 125
Shannon, Terry 52, 56
Shearing, George 96
Sheldon, Don 116
Sheldon Jack 74, 123
Shew, Bobby 113, 130
Shirley, Denis 23

Short, Charlie 6, 10
Simmons, Ron 24
Simmons, Jimmy 20-1, 23, 30
Sims, Zoot 38, 40
Sinatra, Frank 64, 77
Sinatra, Nancy 64
Sinatra, Spencer 37
Singer, Harry 7
Singleton, Zutty 4
Skidmore, Jimmy 7, 22
Skymasters, The 21
Smith, Tommy 20
Smokey Joe's 86
Sowerby, Bill 21, 25, 30
Spivak, Charlie 2
Spooner, Al 50
Sportsman's Lodge Hotel 95
Stapleton, Cyril 48
Stark, Bill 50
Stash, Bill 50
Stobart, Kathleen 20-1, 30
Stout, Ron 125, 129
Strazzeri, Frank 80, 116
Stephane Grapelli Quintet 9
Streisand, Barbra 85
Summers Bob 130
Sutcliffe, Bill 51
Sutton, Tierny 83

Takvorian, Tak 11
Talbert, Tom 92
Tano, Vinny 37
Teagarden, Jack
Tennent, Billy 48
Thirwell, Jack 25
Thomas, Terry 8
Thompson, Lucky 34
Thorne, Ken 7-8, 22, 70, 120, 132
Thornhill, Claude 70
Torme, Mel 55, 91

Traxler, Gene 2
Trombone Festival, Windsor 115
Trujillo, Bill 97
Turnbull, Gordon 52, 56

Usher Hall, Edinburgh 42

Vax, Mike 97
Vic Lewis and Jack Parnell Jazzmen 6
Vic Lewis Bopsters and Orchestra 13
Vic Lewis Charity Cricket XI 118
Vic Lewis Jazzmen 7
Vic Lewis Orchestra 43-7, 50, 56
Vic Lewis Swing String Quartet 1
Vorster, John 88

Wagner, Bill 58, 81
Warner, Peter 21
Washington, Dinah 53
Watson, Johnny 32
Watts, Arthur 52, 56
Wellins, Bobby 50
Wettling, George 4
Wheaton, Jack 95
Wheeler, Kenny 47, 50
Whigham, Jiggs 66, 69, 88, 100, 105, 112, 120
White, Andy 32
Whittle, Tommy 29
Wigham, Jiggs
Williams, Marion 30
Williamson, Claude 105

Wilson, Andy 32
Wilson, Jimmy 7
Wigfield, Les 43
Winding, Mats 106
Winslow, Peter 21, 30
Wisdom, Norman 8
Woods, Phil 123
Worthington, Tom 116
Wright, Edythe 2

Young, Lee 60
Young, Lester 3
Young, Trummy 28

Zudekoff, Moe (see Morrow, Buddy) 2

 Copper Scroll

London N20 OEG

e-mail: mail @copper-scroll.com

ISBN: 0-9552953-0-0
978-0-9552953-0-0

978-0-9552953-0-0

Printed and bound in China through InterPress Ltd